MURDER & MAYHEM IN BOSTON

HISTORIC CRIMES IN THE HUB

CHRISTOPHER DALEY

CATHERINE REUSCH DALEY, PHOTOGRAPHER

Published by The History Press
Charleston, SC 29403
www.historypress.net

Copyright © 2015 by Christopher Daley
All rights reserved

First published 2015

Manufactured in the United States

ISBN 978.1.62619.797.8

Library of Congress Control Number: 2015943863

Notice: The information in this book is true and complete to the best of our knowledge. It is offered without guarantee on the part of the author or The History Press. The author and The History Press disclaim all liability in connection with the use of this book.

All rights reserved. No part of this book may be reproduced or transmitted in any form whatsoever without prior written permission from the publisher except in the case of brief quotations embodied in critical articles and reviews.

To my wife, Cathy.

CONTENTS

Acknowledgements	7
Introduction	9
1. The Prostitute and the Somnambulist: The Maria Bickford Case	13
2. Monster in the Woods: The Bussey Woods Case	32
3. The Boston Barrel Butchery: The Leavitt Alley Case	43
4. The Boston Skull Cracker: The Thomas Piper Case	62
5. Sadistic Youth: The Jesse Pomeroy Case	78
6. The Unrelenting Cop: The Price-Corey Case	102
7. Death Comes to Prince Street: The Joseph Fantasia Case	114
8. Dismembered: The Grayce Asquith Case	135
9. The Giggler: The Kenneth Harrison Case	150
Bibliography	157
About the Author	160

ACKNOWLEDGEMENTS

First, I would like to thank my wife, Catherine Reusch Daley, not only for her outstanding photographic contributions to this book but also for her patience with me in this endeavor. Many a time I was sequestered with my writing and research and was not available for the things that a husband should be there for. Nonetheless, she was always encouraging and supportive to me.

There were many people who helped in the creation of this book—most notably Captain Jack Daley (no relation) of the Boston Police Department (retired). His insight into the "Giggler Case" was indispensable. Others whom I would like to thank are Robert Zinck and Yahau Li of the Widener Library at Harvard University; Ann Swartzell from Patron Services at Harvard University; Dominic Hall, curator of the Warren Anatomical Museum at Harvard University; Lesley Schoenfeld of Historical and Special Collections, Harvard Law School Library; Elizabeth Roscio of the Bostonian Society; and Jane Winton and Tom Blake of the Boston Public Library Print Department.

Lastly, I would like to thank the great team at The History Press: my commissioning editor Tabitha Dulla, my production editor Elizabeth Farry and Leigh Scott, the sales manager at the parent company Arcadia Publishing.

INTRODUCTION

The book *Murder & Mayhem in Boston* really began when I developed a historical presentation entitled "Mass Murder: Massachusetts' Most Notorious Murder Cases," which I have been delivering at historical societies, public libraries and various organizations for years now.

The idea for *Murder & Mayhem in Boston* was put before me by The History Press—to take some of the research that had been already done with respect to murder cases in Boston and expand on that. So, I was able to take some of my previous research from "Mass Murder" that focused on Boston and combine it with new research on other cases—some which are little known to the public.

In the course of my research, I sifted through many cases—some of which have already been exhaustively addressed in other works such as the Boston Strangler and the Parkman-Webster Case, which I chose not to include in this volume just for that fact. Of the many others, some just didn't have the outstanding qualities to warrant publication. I wanted to include lesser-known murder cases that had something out of the ordinary, and I was able to put together nine chapters of stories that had some mystery involved, some kind of a twist or something so shocking that the story had to be told.

The chapter "The Prostitute and the Somnambulist" is about the Maria Bickford case and is a story about which not much is generally known—other than that the case stands out in the annals of criminal law for the unique defense of somnambulism or sleepwalking. This is a story that is descriptive, full and detailed. Several rare and unknown sources were used to document

INTRODUCTION

the story of Maria's sad descent into a life of vice and dissipation—a life that would eventually lead to her death.

The tale of the Bussey Woods murders is another that has been lost in the mists of time; it has been revitalized in the chapter "Monster in the Woods." In this chapter, we find that two innocents, a brother and sister, have been brutally murdered while on a picnic in 1865. Several investigations were begun and suspects identified, but no one was ever charged. Still, today, the case remains an unsolved mystery.

In "The Boston Barrel Butchery," a dismembered body is found stuffed into two barrels—floating down the Charles River. When the contents of the barrels and the body parts are examined, some very interesting clues are discovered that lead to one Leavitt Alley. Later, blood is found in Alley's stable and on his clothing. At trial, it all comes down to whether the blood is human or that of a horse—a nineteenth-century version of *CSI*!

The case of "The Boston Skull Cracker" has been chronicled by other authors in the past and is usually referred to as the "Boston Belfry Murder." Through exhaustive research, I was able to bring to light much more information that has not been previously published, and I was able to find an unknown photograph of Thomas Piper, the murderer, in the archives at the Harvard Law School Library. Through the use of old newspaper accounts and archival material, we learn the story of a loner who lived in his own world, drinking whiskey and laudanum and reading dime novels—the story of a man whose maniacal fantasies turned into homicidal wreckage.

"Sadistic Youth," or the Jesse Pomeroy case, is probably the most well-known case in this volume. The case has been chronicled in several books and numerous articles. It is also the most shocking and frightening story, detailing the utter depravity and inhumanity of a boy who has been dubbed "America's Youngest Serial Killer." The tale of his crimes is riveting as is the history of his fifty-eight-year imprisonment and of his numerous escape attempts. The chapter also includes a recently discovered mugshot of Jesse that has never before been published.

"The Unrelenting Cop" is a wonderful detective story. A woman is found brutally murdered in a Tremont Street hotel room, and soon Officer Thomas Harvey is on the case. We follow him as he turns over every stone and chases down every lead—until he finds his man. His prisoner is soon charged, indicted and tried—but the ending is very much unexpected and the outcome singular.

In the chapter "Death Comes to Prince Street," gangster Joe Fantasia is shot down in the street in the spring of 1927. But it's not a gang hit!

INTRODUCTION

The questions of motive and identity of the murderer are answered by so many twists and turns that the story would be perfect as the basis for a great crime novel.

In the chapter "Dismembered," female body parts contained in burlap bags begin washing up in Boston Harbor—all except the head. A massive search ensues all over New England to find the identity of the woman. The only thing detectives have to go on is a size-three foot with a small callus on the heel as the only distinguishing feature on the body. The trail leads to a woman's bungalow in the town of Weymouth. In the house, police find a bathroom splattered with blood, with one bloody footprint on the tile floor and one bloody handprint found on the side of the tub. When the tub is removed, bits and chunks of flesh are found stuffed into the pipes. After some good detective work between the Boston police, state police and the Weymouth police, the murderer is caught—but did they get the right man?

The chapter entitled "The Giggler" is about one of the most overlooked cases in the history of Boston crime. Several seemingly unconnected murders are eventually found to be the work of one killer who styled himself "the Giggler." I was able to gain valuable insight into the investigation and capture of the culprit through discussions with a former Boston police detective who worked the case in order to resurrect the forgotten case of "the Giggler."

It has been a fantastic journey researching and writing about these historical cases—reading the old newspaper articles, viewing the ancient crumbling documents and photographs, locating the original crime scenes and other sites and then distilling it all down into entertaining and fascinating chapters. My wish is that these stories will be every bit as exciting and exhilarating to read as it was to investigate them and commit them to paper.

—CHRISTOPHER DALEY
Pinehurst Beach
Wareham, Massachusetts

1
THE PROSTITUTE AND THE SOMNAMBULIST

THE MARIA BICKFORD CASE

The October 27, 1845 headline of the *Boston Daily Mail* shouted, "Horrible Murder and Attempted Arson in Boston." Beneath the headline, the news article read, "A woman was murdered this morning about 4 o'clock at a house in Cedar Lane, near Cambridge Bridge, recently occupied as a house of prostitution by the notorious Julia King." Thus was Boston's first exposure to the plight of Maria Bickford and the beginning of a story that would enthrall New England and the nation with the lurid details of her life and the trial and acquittal of her former lover Albert Tirrell through the use of the novel defense of somnambulism.

Maria Bickford was born on June 19, 1824, as Mary Ann Dunn in Bath, Maine. She was described as having "great personal beauty and fascinating manners." She later moved to Bangor, Maine, where she met James Bickford from the town across the river—Brewer, Maine. They were married there in March 1840 and had a beautiful daughter on January 7, 1841, who they named Mary Elizabeth, but tragically, sixteen months later, the baby lay dead. In *The Authentic Life of Mrs. Mary Ann Bickford*, originally written as a newspaper serial in 1846, an unnamed chronicler tells us, "This domestic affliction had a powerful influence on the mind of the mother, bordering on insanity." When one reads the sad account of her life in its entirety, the question arises as to whether the loss of a child was the causal effect of her downfall and entry into a life of dissipation and degradation. One can only guess.

Shortly after the death of her daughter, Maria (as she would later be called) was invited by a group of female friends to make a trip to Boston. Coming

MURDER & MAYHEM IN BOSTON

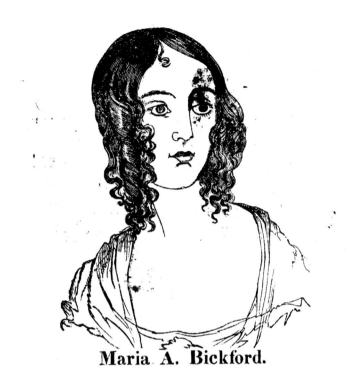

Maria Bickford. *Image courtesy of the Weidner Library, Harvard University.*

to Boston, the "Hub of the Universe," seems to have been a life-altering event and a turning point for the young grieving mother. When she arrived, she was "highly delighted with everything she saw. The gorgeous jewelry, the splendid goods for sale in the various stores on Washington Street, she would often refer to and as often express a strong desire to remain there permanently." But when she returned home, she took on an accentuated despondent tone. She gave the impression that she was deeply unhappy with her situation and appeared to have come to a more acute realization of her husband's limited means; she no longer wanted anything to do with backward provincial Bangor but wanted to enjoy the fashion, gaiety and bustle of what she might have seen as the cosmopolitan city of Boston.

Probably due to financial constraints, in July 1842, the Bickfords had to move. They chose a cheap boardinghouse owned by a Bangor widow. It was here that Maria would meet a man known to history only as "Johnson." The author of her serial biography would describe how Johnson "seduced" her: "His prepossessing appearance and bland manners, with the assistance of a female friend, soon biased the judgment of Mrs. B., whose mind was

HISTORIC CRIMES IN THE HUB

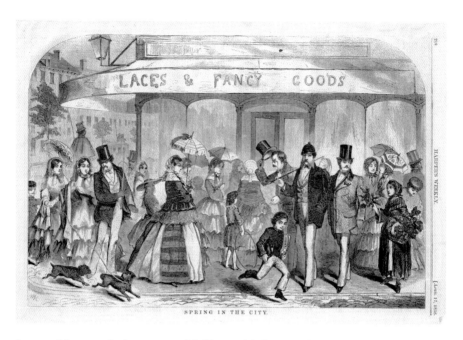

Laces and fancy goods. *Image courtesy of the Trustees of the Boston Public Library/Print Department.*

already ill at ease, and she received his addresses favorably; he soon won her confidence, and consequently had her completely in his power." He told her everything she wanted to hear. She would have all that she desired—the finest clothes and jewelry—and, most important of all, he would take her to Boston. In October 1842, Johnson was able to spirit young Mary Ann Bickford away from her husband to Newburyport, Massachusetts, where her journey into vice would begin.

 The couple spent a few months going from hotel to hotel, but when Johnson tired of the young girl and ran out of money, he finally did bring her to Boston but left her in a "house of ill-fame" and vanished. From a perusal of Maria's letters to her ever-forgiving husband during this period, it is quite clear that she was in Boston and led him to believe that she was still in Newburyport. Her letters play on his pity, explaining that she tried to work in a factory but fell ill and that she owed her landlady rent and the doctor money for treatment. She begged him to send money and even said that she might return to him. However, she admonished him not to seek her out in Newburyport because he wouldn't be able to find her there, and she closed her letter by instructing her husband to "let no one see this…when you direct your letter send it to Boston and I will get it." It appears that

James sent no money and did not seek her out. One may wonder if he knew she was trying to deceive him.

In a subsequent letter, she informed James that she had "moved" to Boston but was still in poor condition and needed money. She further explained that she lived at 16 Margin Street under the name Maria Welch, touting it as a "genteel house." In another letter, she would state that she was in a "respectable boarding house; I would not have you think to the contrary." She made several overtures for James to come to Boston and set up "housekeeping" with him again, however, not at North Margin Street but at some rooms over on Endicott Street. He decided he would reunite with her and made plans to go to Boston. Then he received the following letter:

> Sir—I feel it is my duty to inform you that your wife is living a life of prostitution in this city. She has been living for some time in a house of ill-fame in North Margin Street. I hope it may be in your power, either by admonition or other-wise to reclaim her from the disorders and vices to which her present course of life will inevitably bring her.
>
> Very Respectfully,
> Emeline Hovey—A friend of virtue

If James had any suspicions about his wife's doings, now they were confirmed. Surprisingly, he decided to go to Boston anyway. James did not give up on his Mary Ann, a pattern that he would consistently show throughout her tragic short life. He would always be there for her no matter what she did, but he did have his boundaries, as we shall see.

North Margin Street was located in Boston's "North End." By the 1820s, the North End had become a magnet for gamblers, criminals, prostitutes and sailors on leave from their ships docked on the North End's wharfs. Specifically, the area around Ann Street, just up the street from the wharfs, was the most notorious. It came to be called "Black Sea" due to the utter depravity, debauchery and licentiousness that occurred there nightly. In 1883, author Edwin Bacon noted, in his book *The King's Dictionary of Boston*, "A few years ago, comparatively, these streets, particularly North (more anciently Ann Street), were almost wholly devoted to sailors' boarding and dance houses, and other dens of iniquity. Every ground-floor, and many a cellar, was a bar-room and dancing-floor combined."

Although North Margin Street was not in the "Black Sea" but just a few blocks away, it was an area where there were several "houses of ill-fame." Interestingly

enough, during recent excavations for Boston's "Big Dig" (the creation of the "Tip O'Neil" Tunnel), the remnants of one such house were uncovered on what was the end of Endicott Street, the street right next to North Margin and in a location that was probably within feet of number 16 North Margin Street. Over three thousand artifacts were recovered from the site, and they give us quite an insight as to what the life of a nineteenth-century prostitute was like. In an interview done for *Bostonia*, archaeologist Mary Beaudry told of her findings at Endicott Street: "The archaeologists have deduced, unsurprisingly, that personal hygiene was of great importance to these women. In addition to medicines and syringes, they found toothbrushes, hair combs, and tooth powder, a rare and luxurious commodity given that people seldom brushed their teeth."

She further related:

> *The madam managed to create an atmosphere that mimicked the middle-class home. This kind of brothel was referred to as a parlor house, because there were furnishings that sort of looked like a middle-class parlor. The brothel apparently offered gambling, meals, and "special services," which would take place in a private room for an extra cost. Because the team found many different dinner and tea sets, they believe the home was able to serve several different clients at once.*

However, also found at the site were many syringes and medicine bottles. The archaeologists concluded that these were used for the various reasons of prevention of pregnancy, treatment of venereal disease and abortion.

James arrived in Boston on February 24, 1843, and proceeded to 16 North Margin Street to find his wife and try to pluck her from the life she had fallen into. When he called at number 16, he was told by those at the residence that Maria had been gone some three weeks. At that, James searched the city for his wife and sent several letters to her hoping that they would find her through the service of the post office. Finally, after calling at North Margin Street once more, a meeting was set up between the two. Promises and plans were made, Maria said that she would come back to James, an address was found and all that needed to be done was to move in together. But before the promises could be kept and the plans carried out, Maria met yet another "fancy man."

In a letter to a friend she related:

> *Oh I ride with the handsomest man Boston affords; and we have three of the most magnificent robes that you ever saw...he has got me a splendid foot muff, and, oh such a splendid sleigh! And two of the most splendid*

horses you ever saw—he has run three races with me in the sleigh and that is considered considerable for a woman up here.

She closed the letter to her friend by speculating that the folks back home would probably "talk about me like the devil."

Soon after, James would receive a missive that read:

James—I've deceived you. I couldn't bear the idea of living so retired, after seeing such genteel company. The people where I board do not know that I have got a husband, and that is the reason I cannot let you know where I am.

James I feel very unsteady now; but will consent to live with you and keep house, if you will let me have my liberty. If you will consent to do so, I will live with you.

*Yours,
Maria Bickford*

Essentially, what Maria was asking her husband to do was allow her to continue as a prostitute while living as man and wife. This was one boundary he would not cross, and he quickly answered her letter expressing his shock and dismay that she would even suggest such a thing. However, he stayed in Boston, remained in contact with Maria and continued to try to persuade her to leave the life was leading.

Soon, she was set adrift by her "fancy man" and found herself in poverty once again. In her letters to James, she petitioned once again for funds and continued to allude to returning to marital monogamy. He came to her assistance, but as before, she did not return to him and arrived back at North Margin Street. As the chronicler of the newspaper serial states, she "became more generally known in the city as wanton."

Finally, in June 1843, Maria moved in with James, but it only lasted a few months. Before long, as James would find, she was plying her trade from their apartment while he was away or at work. Upon the discovery of her conduct, he left her. For the next year or so, she went from one wealthy man to the next and always would find herself left behind and in poverty after a short stint in luxury and grandeur. It appears that by July she had hit a new low. She decided to remove to the city of New Bedford and take up residence in its notorious "Hard Dig" neighborhood.

Maria's words describe the "Hard Dig" better than any chronicler could. She wrote to James: "I live in the 'Hard Dig,' the vilest place that was ever made.

HISTORIC CRIMES IN THE HUB

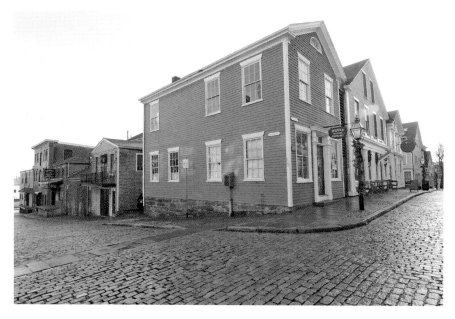

New Bedford, Massachusetts. *Original photograph by Catherine Reusch Daley.*

Here are five bad houses altogether. The inmates are getting drunk and fighting all the time. They drink and fight all day, and dance and ——— all night."

Once again, she was imploring him to send money, and once again, he did. In his response to her, he stated, "I will not forsake you, for I believe I can yet, by assistance of providence, work out your redemption—at least, I shall endeavor. Do reflect on your downward course!"

In November 1844, James Bickford did go to New Bedford's "Hard Dig" to make another attempt at redemption and reconciliation only to find that Maria was no longer there but at the fashionable Railroad House Hotel and that she was living with a wealthy businessman by the name of Albert Tirrell. James found that, although Tirrell was married, he and Maria were living as man and wife and that, once more, she was living in opulence and had no need for James. Upon seeing that there wasn't the remotest possibility of changing his wife's mind, James slunk back to Boston.

At first, it looked like Maria had finally found her man. Albert Tirrell was a traveling businessman. He and Maria traveled all over—Philadelphia, Albany, Saratoga Springs and so forth—staying in the finest hotels, drinking vintage wines and wearing the best clothes. Maria was in heaven! They normally would register as Mr. and Mrs. Jackson, stay out of public view and take their meals in their room. But soon, they began to quarrel, and Maria

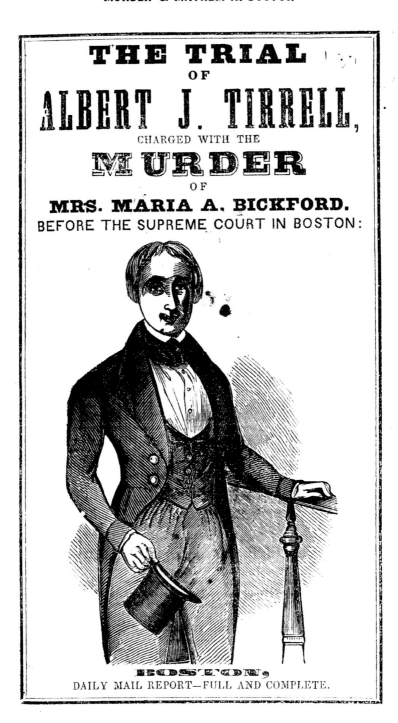

Albert Tirrell. *Courtesy of the Weidner Library, Harvard University.*

found that her dream man wanted total and utter control of her. On one occasion, Tirrell literally cut and tore from her one of the beautiful dresses that he bought for her—what he gave he could just as quickly take away. The fights got so noisy that they were kicked out of several establishments. One hotelier, suspecting something wasn't right, found that Tirrell had a wife and children in the town of Weymouth and asked them to leave. Before long, a warrant was issued for Tirrell's arrest for the crime of adultery. Learning of this, Tirrell decided that he would set Maria up in her own house and "furnish it elegantly." The house was located on London Street in East Boston. It was there that he was approached by two men claiming to be police with a warrant; they frightened him a bit but agreed to forego serving the warrant for the price of $100. Shortly thereafter, Tirrell sold the house at a loss. Whether this was due to the heat of the law coming down on him or the fact that Maria had left him and gone back to Maine is unknown, but what we do know is that he followed her to Maine thereafter. He went to her mother's house and, finding that she wasn't there, left a note enjoining her to come back to him in Boston and that he would "furnish her with plenty of money etc, etc." It was observed by the newspaper chronicler, "It is manifest, by his singular conduct, that he had become completely infatuated with Mrs. B."

Maria was no longer in Maine but made a short stop in Boston and then headed back to the "Hard Dig" to hide out. It was here in June 1845 that she composed a letter to her husband expressing that she knew Albert was looking for her and that when he did find her, she "expected to be killed." Albert did find her, and at this point, they began traveling from hotel to hotel. Whether Maria was willing is hard to ascertain. Several letters were exchanged between Maria and James, generally in order to arrange to have some of her possessions shipped to where she was living with Tirrell.

When examining the letters from Maria to James at this time, one can almost imagine Albert Tirrell standing over her as she wrote them. They have a different tone, seemingly stilted and unfeeling. Some evidence of how she was being treated comes down to us from a friend who happened to bump into Maria in Boston and was able to talk to her free of Albert Tirrell's gaze. The friend related a story about how Tirrell was becoming short of cash (probably as the result of squandering his inheritance) and how he brought Maria on a carriage ride to ask her for some of the expensive dresses he had given her so he could sell them. Maria refused. At this, said the friend, Tirrell had knocked Maria down and threatened to kill her as she begged for her life and promised to do anything he wanted.

MURDER & MAYHEM IN BOSTON

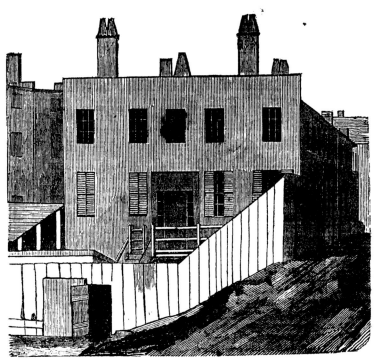

The House where the Murder was Committed.

House on Cedar Lane. *Courtesy of the Weidner Library, Harvard University.*

In early October 1845, the pair was separated not by choice but due to the fact that Albert was arrested on adultery charges and jailed. This was Maria's chance to escape, and that she did. She took up residence in a known house of prostitution run by a Mr. Joel Lawrence and his wife on Cedar Lane (also known as Mount Vernon Avenue) off Charles Street near the Cambridge Bridge, now called the Longfellow Bridge. When bailed, Albert desperately searched for Maria, even going as far as writing to her husband to find her whereabouts.

Eventually, Tirrell did find Maria. Witnesses said that he visited her frequently in the waning days of October. On October 26, a fellow "boarder" named Priscilla Blood said that she overheard the couple quarrelling between three and four o'clock in the afternoon. Mrs. Lawrence, wife of the landlord, Joel Lawrence, said that she had seen them together that day and the last she saw the both of them was at ten past nine o'clock that night. Mr. Lawrence

would later testify that he shut the house up at nine o'clock and that Tirrell was still in the room with Bickford for the night.

Just after four o'clock in the morning, a scream was heard throughout the house. A few minutes passed, and then there was the sound of a thud, as if a body had hit the floor. Mrs. Lawrence would later state that directly afterward she heard someone running and stumbling down the back staircase and then going out the back door. She then decided to investigate the scream and began to ascend the stairs and came to the landing where she found a pile of bedclothes on fire. Her husband, who had been sleeping in another room on the first

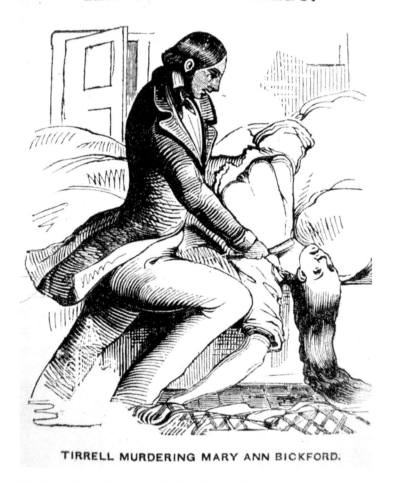

Tirrell murdering Mary Ann Bickford. *From the* National Police Gazette.

floor, arrived on the scene shortly after. He would later testify that he heard a man stumbling down the stairs, then opening the door and running out. Shortly thereafter, Lawrence also heard "somebody making a screeching noise." It was then that he heard his wife cry, "Fire!" and at that, he rushed up the stairs to the landing, where he found the set of burning bedclothes. He quickly took them and threw them in the backyard.

Fireman Theodore Bowker, who lived at the corner of Pinckney and Charles Streets, heard the call of fire, got up and ran to the Lawrence residence where he heard the screams coming from. When he got there, he saw Joel Lawrence emerging from the building, asked him what had happened and was told, "The trouble was over and the fire was out" and not to bother going in. Bowker sensed something wasn't right and pushed by Lawrence to run up the stairs only to find that the fire was still going. He quickly organized a makeshift bucket brigade and soon had the flames out.

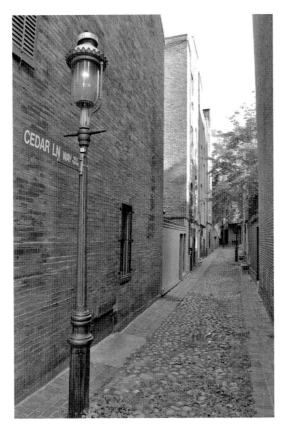

Cedar Lane Way. *Original photograph by Catherine Reusch Daley.*

Later, Bowker would state that while in the smoke-filled room, "I stumbled over an object that I thought was somebody laying on the floor. It nearly threw me down. I ran out and got a light, and found a dead body on the floor with the throat cut as to expose the bone. The body had nothing but a chemise on, which was drawn up on the breast. I did not feel the body to see if it was warm…I told Lawrence to cover the body, and he took a sheet from the bed which fell heavily as though it was saturated with blood."

The Boston police arrived on the scene shortly after Bowker, followed by Jabez Pratt, the Boston city coroner. He inspected the body and the

HISTORIC CRIMES IN THE HUB

The Murder of Maria Bickford
October 27th, 1845

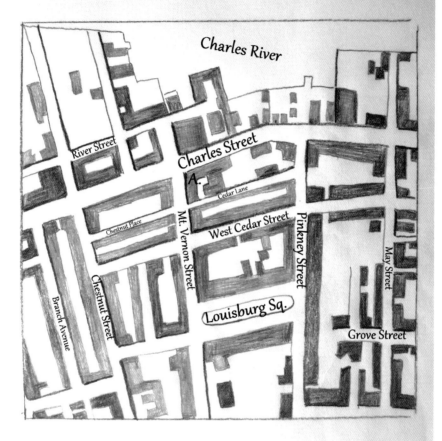

A. Location of murder house

Location map. *Map by author.*

scene and observed that "the body lay on its back, in an angular position, her head about a foot and a half from the grate. Right elbow was bent, and the head inclined to the right." Describing the wound, he would say, "A large gash was seen on the left side of her neck before moving the body. On turning over the body, a gash was discovered across her neck, clear round laying it open." He also would note that there had been an attempt to burn the body: "Her night clothes were burned off close up to her breast, leaving

part of her stays and chemise. Her face was smeared not burnt much. The body was badly burned but not deep." Pratt also found what he thought might be the murder weapon: "A little to her right, two feet from the right arm lay a razor, open and smeared with blood." He pointed out the spot in the room where Maria Bickford was slain, which was on the bed, not on the floor where the body was found. "There was a large spot of blood on the mattress, and in taking up the mattress, the blood had run through onto the straw bed. The place was the circumference of a large pail." There was also an indication that the murderer tried to wash up as Pratt found a washbasin partially filled with bloody water. Pratt also discovered several other objects of interest: an earring that appeared to have been torn off the victim; a ring from the victim's finger that was inscribed inside, "A.J.T to M.A.B."; a cane; a cravat; and a vest. In the vest were some keys marked number 9 Elm Street where, as it later turned out, Tirrell's hotel room was. When detectives went to the room, they found a trunk with underwear and a pair of stockings. One of the stockings appeared to be burnt, and both underwear and stockings had blood on them, which indicated that Tirrell had gone back to his hotel room before leaving town.

 Detectives would find that Albert fled the boardinghouse, ran to the home of his friend Samuel Head at 2 Alden Court and woke him. Head would later testify that Tirrell seemed in a "stupor" and began babbling that he had clothes at the address and had to come pick them up. Both Head and his wife, who had opened the door, looked at each other in wonderment, having no idea what Tirrell was talking about. Head then had to shake Tirrell to "wake him from his stupor." When he seemed to come to his senses, Albert asked how he had gotten there and then left. It was assumed that at this time he went back to his hotel, changed and then went to the livery stable of James Fullam.

 Detectives traced Albert's movements to the livery stable and found from owner James Fullam that Albert arrived there around 5:00 a.m. and said that he had gotten into some trouble—that someone had broken into his room and tried to murder him—and that he wanted to hire a man to bring him home to Weymouth. Fullam added that he had his man Oliver Thompson take Tirrell home in a covered wagon. Detectives were quickly sent out to Weymouth to find Tirrell—but to no avail. Days later, it would be found that he fled the state. From Weymouth, Tirrell traveled through Vermont to Canada. In Montreal, he booked passage on a ship to Liverpool. Bad weather caused the ship to return to port. Next, he made his way down to New York, and it was there that he booked passage on a ship for New Orleans.

HISTORIC CRIMES IN THE HUB

Word had gotten out where he was headed and the police in Louisiana were alerted, and on December 5, they boarded the ship and arrested Tirrell. He was hurriedly sent back to Massachusetts for trial.

The prominent Tirrell family had founded the first shoe manufactory in Weymouth in 1808 and by 1846 had amassed a great fortune. The family banded together and got their wayward son the best lawyer money could buy. That man was Rufus Choate.

By 1846, Choate had served in both the Massachusetts house and senate and had served one term as the U.S. senator from Massachusetts. He was renowned for his oratory skills and had made quite a name for himself as an attorney by winning several hard-fought cases.

Choate had three months in which to prepare his case, and after talking with Albert, he developed a two-pronged defense: either Maria killed herself, or Albert killed her while sleepwalking. For this time period, the sleepwalking defense was a bold and somewhat risky defense tactic. Somnambulism, as it was called, was quite unknown to the general public, and no one had ever successfully used this as a defense in the past; nonetheless, Choate pressed on.

The trial began on March 24, 1846, to great fanfare. The courtroom was standing room only, and all of the Boston newspapers had reporters on hand. One reporter quipped, "From the anxious countenance of the eager multitude, and other demonstrations in and about the courthouse, one might be led to suppose some great event was to take place, or some new era burst upon the world."

The prosecuting attorney, Samuel Parker, began the trial with his opening remarks before Judges Dewey, Hubbard and Wilde and the jury indicating that Albert Tirrell did willfully and with malice kill Maria Bickford. Parker outlined his case, telling the jury that he would show that the defendant was guilty due to his conduct before and after the murder, the way the body was found, evidence that he washed his hands, the attempt to burn the body and his flight from prosecution, including the use of disguises and aliases. After the opening remarks, he began to press his case by introducing the witnesses.

The initial witnesses set the scene and described the murder in graphic detail. First the coroner Jabez Pratt described the death scene—the blood, the gore and the razor. Physician Joseph Moriarty, one of the coroners who performed the coroner's inquest, was also called. He testified to the nature of the throat wound. When asked upon cross-examination, he said it might be possible for the wound to be self-inflicted by someone in a state of high excitement but thought it was unlikely, stating that he had never seen a

suicide by razor blade. Subsequently, the boarders at 76 Charles Street and Mr. and Mrs. Lawrence described the events of the prior evening and the early morning the murder occurred, as did fireman Theodore Bowker.

Then Mr. and Mr. Samuel Head, James Fullam and various other witnesses were brought in to testify to the flight of Albert Tirrell after the murder and what was found in his trunk.

Finally, a stream of witnesses—including Maria's husband, James—testified about the ongoing adulterous relationship, as well as the bickering and fighting between Maria and Albert. The prosecution rested its case. The case was almost entirely circumstantial but strong.

The opening arguments for the defense were made by Choate's assistant Annis Merrill. Merrill launched into his defense by proclaiming that Albert had received a raw deal from the press accounts at the time and that many of the reports of the crime were either wrong or purposely embellished with libelous facts to titillate the reader. He admonished the jury not to base its judgment on those accounts but on the facts presented in court. He also reminded the jury that the defendant was innocent until proven guilty and that it was the job of the government to convince it beyond a reasonable doubt of that guilt. He next began to explain to the jury that the prosecution's case was only circumstantial and went into a long diatribe about how defendants who were later found innocent were convicted at trial by circumstantial evidence. Finally, Merrill got to the meat of the defense. He first offered that the victim might have herself taken her own life in a suicide. Then Merrill spent the rest of the opening on another aspect of the defense—somnambulism. The defense attorney proffered that Tirrell was a victim of sleepwalking, also known as somnambulism. He gave a layman explanation of what it was and cited several prominent studies on the conditions. At one point, Merrill even compared Albert's condition to "temporary derangement."

The defense would attempt to prove that Albert had long been a victim of this condition and that if he did murder Maria Bickford, it was not willingly but under the grasp of this dreadful malady.

Lead attorney Rufus Choate now took the reins and began to introduce witnesses. Many of the witnesses would be brought forward to give testimony about Albert's lifelong affliction—sleepwalking. Mrs. Nabby Tirrell, the mother of the defendant, was the first witness to attest to her son Albert's condition. Under questioning, she explained that he had begun to exhibit the symptoms of somnambulism by the age of four or five. Over the years, she said, she had found him walking in his sleep many times and that he

would always make a "singular noise" when doing so. She tried to imitate it for the court, and it was noted that it was a sound of distress. She gave several examples of his sleepwalking, but one in particular seemed to stick out. She said that around the age of seventeen, he got up, "tore down the window curtains, broke the glass and cut his hand." She remarked that his condition brought the family so much anxiety that they had to bar the door to his room when he was sleeping.

Albert's brother, Leonard Tirrell, was next to take the stand. He remarked that Albert always made a strange noise when he was sleepwalking. Leonard also recounted that when he slept in the same room with him as a child, Albert would attack him while in a sleep trance and that it was very hard to wake him.

Minot Richards, a friend of Albert's, took the stand. He testified that he had stayed at the Tirrell house on numerous occasions and had slept in the same room with Albert at times. Like the others, he noted the strange noise but also said that one time it took him fifteen minutes to bring Albert out of his stupor during a somnambulistic event.

Then the defense turned to attacking the victim. They began by calling Emily Amelia Tirrell to the stand. She was the wife of Albert's cousin Joel from New Bedford. Maria and Albert had spent some time living as man and wife in the company of Albert's cousin and his wife at their "boardinghouse" and then later at two local hotels: the Railroad House and the Mechanics Hotel. By living in such close quarters with both Albert and Maria, Emily had a unique view into the lives of the two.

Emily had much to say about Maria. She stated that Maria carried dirks (daggers) and razors with her, drank to excess and took laudanum (a liquid opiate). She explained that she first met Maria at a house of ill fame and that she "carried on and broke things," recounting that she saw Maria throw a decanter into a fireplace and throw a washbowl at Albert during another fit of anger.

Next, Joel Tirrell, Albert's cousin and Emily's husband, took the stand. In his testimony about Maria, he implied that she had been working as a prostitute in New Bedford when Albert met her. He claimed that the "deceased" was known to take laudanum and that at one point she had actually overdosed and required medical attention. He also revealed that Maria possessed a straight razor that she used for shaving her hairline on her forehead.

Joel gave some insight into the allure that Maria seemed to have over men. He said that she "was good looking, fascinating, fond of music and dancing…and was fond of wearing very nice dresses." In his testimony, he

also seemed to indicate that Albert was smitten and controlled by Maria. He told three stories to illustrate this. In one of the stories, he explained that when Albert and Maria fought, Albert would often say to her, "Maria, don't quarrel, I will do anything for you!" In the second story, he told about the time when Albert bought Maria some grapes, but she didn't like them and threw them across the room to show her dissatisfaction. In the third, he related that Albert bought Maria a fifteen-dollar bonnet that during a fight she stomped on and yelled at him, threatening that she would run a knife through him. Joel concluded his testimony by saying, "Albert spent a lot of money on her...She had more dresses than any woman I ever saw."

After the Tirrells' testimonies there came more people with Albert Tirrell sleepwalking stories. Most contained several similar facets: he seemed to be in a daze and was hard to wake, he could become violent and he made a strange groaning noise, very much like the one heard the night of the murder.

After the defense rested its case, both attorneys made their closing arguments. The prosecution went first, and Samuel Parker went through the case detail by detail. He also attempted to poke holes in the defense's somnambulism case by pointing out that Albert seemed to be in full control of his faculties after the murder—being able to move the body, light the mattress on fire, wash up and leave the scene. Parker also noted that Albert seemed to be in control of himself when he went to Fullam's stable but somehow was in a trance at the residence of Samuel Head, implying that the sleepwalking had been feigned.

When Rufus Choate took the floor, the spectators in the court stood in silent amazement, waiting to see the skills of the great orator lavished upon them. They were not disappointed. Choate began his closing plea slowly and quietly. With all eyes on him, he remarked on how Albert had never committed violence before in his life and that his only sin was his fondness for "handsome women." On the other hand, he went on to besmirch the character of the deceased Maria Bickford, outlining her life as a prostitute—a fallen woman—and said that he thought in all probability she had killed herself. He remarked that "suicide is the natural death of a prostitute; in the history of crime and grief—there are a thousand cases of suicide to one murder." He then went on to cite the time she overdosed on laudanum and that she was known to carry razors and dirks and that she had no other friend accept for Albert.

He gave a scenario for what might have happened. He supposed that Maria killed herself, Albert was in a semi-somnambulistic daze and ran out of the

building and that the Lawrences found the body and tried to loot it of jewelry and then attempted to burn it. Choate also offered that Albert did not flee due to guilt over a murder but due to fear over being arrested for adultery.

He closed by saying, "I think, gentlemen, we have laid before you a probable case, and I believe I may now leave the case in your hands undeterred by the noise and clamor that may be made out of doors, and the fear of ridicule. Although old Rome had a bloody code of laws it was a beautiful practice to bestow a civic wreath on one who had served a citizen's life, and I trust each of you gentlemen of the jury will deserve such a token."

Judge Dewy made his charge to the jury, and they were sent out to deliberate. Within two hours, the court was back in session; the jury had reached a verdict. According to the *Boston Daily Mail*, the following transpired: the members of the jury entered and took their seats when the clerk called the roll. The foreman inquired whether the jury had agreed on a verdict.

Answer: We have.
Clerk: Who shall speak for you?
Answer: The Foreman.
Clerk: Albert J. Tirrell, stand up and hearken the verdict of the jury. Mr. Foreman, look upon the prisoner; prisoner, look upon the foreman. What say you, Mr. Foreman, is the prisoner at the bar guilty or not guilty?
Foreman: Not guilty, sir.

At the announcement, the deathlike stillness that pervaded the courtroom was broken by one burst of applause by the spectators in the gallery, which was answered by an immense shout from the crowd in the street. The applause was quickly hushed, the judge regained order and the prisoner was released to reclaim his life.

Albert Tirrell would move back to Weymouth and rejoin his wife, Orient Tirrell. Although it seems he had squandered most of his inheritance, he was able to retain the family mansion. Records indicated that he spent the rest of his life there and made his living as a "huckster." He died on September 12, 1880.

2
MONSTER IN THE WOODS

THE BUSSEY WOODS CASE

The term "serial killer" really didn't enter the lexicon until the 1980s, but they have always been among us. Historical criminologist Louis B. Schlesinger, in his book *Serial Offenders: Current Thought, Recent Findings*, states that "there may have been serial murders throughout history, but specific cases were not adequately recorded." He also suggests that legends such as werewolves and vampires were inspired by medieval serial killers. In the fifteenth century, one of the wealthiest men in Europe and a former companion in arms of Joan of Arc, Gilles de Rais, sexually assaulted and killed peasant children, mainly boys, whom he had abducted from the surrounding villages and taken to his castle. The Hungarian aristocrat Elizabeth Báthory, born into one of the wealthiest families in Transylvania, allegedly tortured and killed as many as 650 girls and young women before her arrest in 1610. The unidentified killer Jack the Ripper, who has been called the first modern serial killer, killed at least five prostitutes, and possibly more, in London in 1888.

A serial killer is, traditionally, a person who has murdered three or more people over a period of time and may go days, months or even years without killing again—a "cooling-off period" between the murders. The motivation for serial killing is usually based on psychological gratification. Most of the killings involve sexual contact with the victim.

Although the 1865 unsolved murders of Isabella and John Joyce in Bussey Woods, in the Roxbury/Jamaica Plain section of Boston, were just two killings, they have all the unmistakable earmarks of one stop during the travels of a serial killer.

HISTORIC CRIMES IN THE HUB

Isabella and John Joyce were originally from Lynn, Massachusetts. Their father having died several years before, Isabella lived with one of her aunts in Lynn, and John lived with his mother in Boston—not too far from their grandmother's house in the South End. Isabella was fourteen years old, described by the newspapers as "having an appearance scarcely less than 18." Her brother, John, was twelve years old and described as small for his age. Isabella was down from Lynn visiting on Monday, June 12, 1865. It was a very warm, sunny spring day. At about ten minutes past eleven o'clock, after attending the morning session at his school, the Dwight School, John arrived at his grandmother's house on the corner of Newland and Concord Streets and discovered his sister was there visiting. Isabella indicated that she would like to visit some woods in the area. It was later reported to the *New York Times* that John said, "I'll show you some first-rate woods" and that the grandmother objected but was consoled by Isabella when she patted her on the back and said, "Don't be afraid, Grandma; we'll be back in time for Johnny to go to school." This was in reference to the afternoon school session, which would commence at two o'clock. Their destination was May's Woods in nearby Roxbury. They walked out the front door and down the stoop into the street waving to their grandmother—who would never again see them in this life.

Just to walk from their grandmother's house to May's Woods (which is now the area of Woodbine, Edgewood, Maywood and Savin Streets in Roxbury) would have taken close to half an hour—a distance of about a mile and a half. Somehow, the two ended up in Bussey Woods (now the site of the Arnold Arboretum) some four miles away. It was supposed that they "took the Forest Hill car, the Dedham turnpike route, rode out to the terminus, and then struck the first road they came to, which led them across the railroad, across the Jamaica Plain Road, and then by a circuit up the hills and further out." This begs the question: why did they change their destination to such a distant location when they had to be back before two o'clock? Still today, no one has been able to answer that question.

When the children did not return, their grandmother was frantic. She was unable to contact the children's mother, as she was out of town with a family making dresses for them, which, as a seamstress, was her trade. The police were notified on Tuesday and began a search. Returning home from her dress making on Wednesday, Isabella and John's mother learned of their disappearance and became visibly shaken and distressed. The search was unfruitful for nearly a week. Then finally, by mistake on Sunday, June 18, Isabella's body was found by two men who were hiking through the

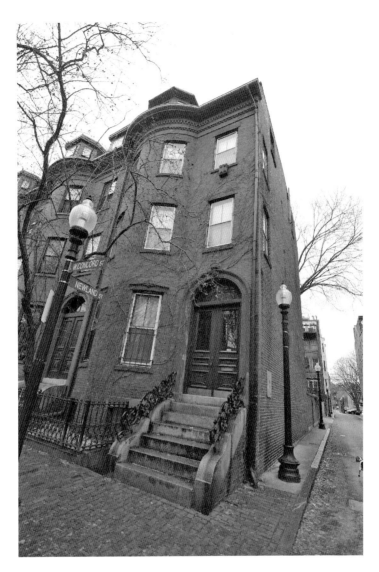

Grandmother Joyce's house in the South End. *Original photograph by Catherine Reusch Daley.*

Bussey Woods area. The newspapers reported the dreadful condition she was found in: "Her body was found flat on the back, from twenty to fifty feet distant from the seat [where it was guessed she had been sitting under an oak tree where oak leaf wreaths were found], and her underclothes torn off. The wounds on her person were in different places, extending from the hips to the breast-bone, and one or two on the back. From an

HISTORIC CRIMES IN THE HUB

Summit of Hemlock Hill, Bussey Woods. Today the grounds of the Arnold Arboretum. *Original photograph by Catherine Reusch Daley.*

examination of the body, Dr. Stedman was led to infer that but one person was engaged in the outrage" (the word outrage being nineteenth-century parlance for rape). Later, according to true crime historian Troy Taylor, in his book *The Northwood Murderer*:

> *The coroner found twenty-seven stab wounds in her torso and another sixteen in her neck. The ground around her body was saturated with blood.*

The location of Isabella Joyce's body—Hemlock Hill, Bussey Woods. *Original photograph by Catherine Reusch Daley.*

She had apparently put up a desperate fight, grabbing the long blade of the knife and trying to wrest it from the attacker's hands. The index finger of her right hand was completely severed and the rest of her fingers were mangled, bloody and hanging loosely by bits of skin. Her clothing was soaked in her blood and clumps of grass and dirt had been roughly shoved in her mouth to try and stifle her cries.

Isabella's body had been found, and attention turned to finding her brother. The search parties scoured the area and it was reported that "several young lads joined, and it was they who discovered the corpse. The nasal organ first revealed its presence, and upon going nearer, one lad cried out that he saw it, and they all took to flight, afraid, and told the police." John's body was found down the hill from his sister, near a stream on its side in the bushes, one arm stretched out and the other under his body. It appeared that he had been stabbed several times in the back—the police guessed while running away. They further supposed "that the boy was for a time amazed or paralyzed by the attack on his sister, and that when he turned to run it was too late."

Their mother was not informed until the next day. The newspapers reported that "upon learning of the fate of her children she

HISTORIC CRIMES IN THE HUB

The location of John Joyce's body—Hemlock Hill, Bussey Woods. *Original photograph by Catherine Reusch Daley.*

swooned, and has since reported to be a maniac." The wake and funeral were held, and both children were interred at Pine Grove Cemetery in Lynn.

Immediately, the investigation ensued. The police's theory was that Isabella had been attacked and that her brother, in a temporary state of shock, could not move. When he regained himself and began to run, the assailant chased him down the hill, stabbing him in the back as he ran, and then finished

him off where he was found by Bussey Brook. It's a wonder they came to this conclusion—it seems they based this solely on the fact that the boy was stabbed in the small of the back. There was no other evidence such as tracks in the dirt or other articles left at the scene because the "crime scene" was obliterated by the search party and then later by the throng of the curious people who came in the hundreds in the days after. The evidence that the girl put up a fight precludes the notion that she was quickly incapacitated and then the boy was chased down. A more likely scenario is that the boy was quickly struck down and then the attacker fell upon his sister and that the boy's body was removed after the fact. The bodies of both children seemed to have been moved and hidden. Isabella was moved in back of a rock, twenty to fifty feet from where they had been making wreaths, out of sight from a nearby path. John was thrown in a wooded area across a stream.

In the days, weeks, months and years that followed, there would be arrests, people would be suspected and confessions would be made. By June 21, just days after the murders, the newspapers declared that the murderer had been caught. Thomas Ainsley, a painter, was arrested, and he certainly looked like a murderer. He occupied the same rooming house as Mrs. Joyce and her son at 6 Cottage Place in Boston, and he was suspected because of his "previous behavior." It seems that Mr. Ainsley had a quarrel or two with Mrs. Joyce and threatened violence, not only to her but to her children as well. However, by the twenty-seventh, the *Boston Post* printed that it was glad to see that the "public was willing to make such reparations as an acknowledgement of injustice may afford, to Thomas Ainsley, who was suspected of the horrible murder of the Joyce children. A slight investigation established his entire innocence and convinced all parties of the danger and wrong of hasty judgment in moments of excitement." Hence, the name Thomas Ainsley was cleared and faded back into oblivion.

Then, on July 9, another man was brought in for the murders. He was a twenty-two-year-old "bounty jumper" from West Roxbury named John Stewart. The *Boston Herald* reported that the chief of police "received information to the effect that John Stewart was the guilty party and that he had confessed his guilt to certain parties." It was further reported that "Detectives Benjamin Heath and William K. Jones, visited the house of an aunt of his in West Roxbury, where he was said to have called on the night of the murder—June 12—with one of his hands cut, and with his clothes covered with blood. Inquiry was made, but the aunt denied all knowledge of the suspected party's whereabouts." Stewart was caught after he enlisted in the army at Fort Independence (Castle Island). It was said, "He denies

all knowledge of the crime, and when spoken to about it said—'I am bad enough, God knows, but I was never bad enough to commit a murder.'— He says he has ample evidence to prove where he was at the time of the murder, and to establish his innocence. He acknowledges to having enlisted and deserted once, and says his greatest fault is drinking." Stewart's "ample evidence" must have sufficed for he, too, was released.

After the arrest and release of John Stewart, there was a short lull, and then in March 1866, there was a break in the case. A prisoner at Charlestown State Prison, who went by the sobriquet "Scratch Gravel"—real name Charles Aaron Dodge—came to the attention of Warden Gideon Haynes. Scratch Gravel was in for burglary and espoused sympathy with the lately defeated Confederacy, but it was hard to tell if he was, in fact, himself a southerner. According to the *Saint Paul Press*, while bragging to other prisoners about being willing to kill a guard to escape, he said, "Do you think the man that did the Roxbury job would hesitate to kill to get his liberty? That was some of my work; I did that job; that bowie knife has sent two d--n Yankees to h--l since I came to Massachusetts." Then he went further and alluded to the crime, saying that "the boy was stabbed in the back and stabbed a good many times, and after an indecent reference to his own person, he said he liked young girls the best, and when he wanted anything of them he generally took it, employing force if necessary." In another conversation with another inmate, he was more specific saying that "he stabbed the Joyce boy in the back several times; and that after having his way with the girl, put her out of the way."

Troubled by the stories Scratch Gravel was telling, some of the inmates informed Warden Haynes. Haynes decided to move Gravel to another cell and introduce a new inmate into the cell with him—only the other inmate was a plant whom we only know publicly by the pseudonym "Semmes." Semmes was a southerner and tried to gain the confidence of Scratch Gravel. In the first weeks, all he could ascertain was that Gravel was not a southerner but actually of Spanish descent and a lifelong New Englander from Massachusetts. As Gravel let down his guard and began to trust Semmes, he "intimated that he had committed murder, and said he had one secret that he would never tell anybody." The two cellmates had many conversations like this where Gravel skirted the issue and didn't come out point blank and say that he had killed the Joyce children.

Finally, Semmes asked one day, "Did you do that job at Roxbury?"

Gravel replied, "How do I know, but are you a detective?" Semmes then insulted him as being a coward, to which Gravel responded with his face in Semmes's face: "I will tell you what I will do; when we go to that window to

get out, you will call Mr. Hall [the prison officer] and I will put a knife into him if that will suit you. There is one affair they [the officers] would like d--n glad to know about, that I was in, and if I was out of this God d--n State, I would tell you something about it."

Semmes was removed the next day, and Gravel was again moved to another cell. Two weeks later, Warden Haynes came down to Gravel's cell and asked him where he had been the summer before. Gravel asked why—but then quickly said, "The Roxbury affair?" The warden nodded and told him he was a suspect and that he needed to know where he was during the time of the murders. It was reported that Gravel "shook and trembled violently, cast his eyes downward and took hold of the door-casing for support." A few days later, under further questioning, he would say that he was in New York at the time of the murders and gave the names of two places that were subsequently found to have never existed. Additional investigation revealed that he was indeed in the area during the time of the murders. He stayed at the Taft Hotel in West Roxbury, which was only three-quarters of a mile from Bussey Woods. Also it was discovered that at the time of his arrest he had been carrying a long double-bladed knife—the kind that was consistent with having inflicted the wounds on the children.

The authorities did some digging and found some interesting things about the life of Scratch Gravel. They discovered that the twenty-seven-year-old had quite a past. The name he was given at birth was Rolla Ampudia, his father being Spanish. He was adopted at the age of four from an orphanage by Aaron Dodge, who had the boy's name changed to Charles Aaron Dodge. By the age of thirteen, he took to the sea and traveled as a seaman all over the world, at one time "hunting Indians by the head in Florida." When the war broke out, he was in jail in South Carolina for murder but was released when he agreed to fight for the Confederacy. Once released, he quickly deserted. He also fought for the Union in several different instances, all of them using assumed names, and at one point was captured by the Confederates and imprisoned.

With all this evidence, Warden Haynes went to the district attorney, B.W. Harris. According to Jamiaca Plain historian Walter H. Marx, "The Boston police were not convinced by the prison warden's reports that Gravel was their man. All his information could have come entirely from newspaper reports. If no stronger evidence came forth, Scratch Gravel would be proved more of a braggart fool who embellished the basic information in the newspapers for his own reasons. Thus rested the matter of Jamaica Plain's most heinous and unsolved murder until it took another bizarre turn."

HISTORIC CRIMES IN THE HUB

The bizarre turn that Marx speaks of was a book published in 1868 by Henry Johnson Brent called *Was It a Ghost?* about the Bussey Woods murders. Brent, a writer and landscape artist staying in the immediate area at the time of the murders, would often tread out into the beautiful meadows and the forests to replicate what he saw on canvas. The day of the murders, he relates in his book, was very hot and oppressive. His plan that day was to walk out to the area of the hill where the two Joyce children would meet their fate. But, due to the heat and the convincing of some of his neighbors, he decided to stay close to his house. In his book, which was written in high Victorian style with its flowery and verbose prose, he tells us in a rather distinct way that he felt a certain regret about not going out that day. He seems to have had a sense of guilt because if he had gone out that day he thought he might have somehow stopped the murders from happening.

The title of his book *Was It a Ghost?* leads one to think that the premise of the book is that a ghost committed the murders. When reading Brent's book, we meet a man greatly affected by the murders, very saddened not only by the tragedy of the loss of two children but also disturbed by the pall cast over Bussey Woods, to him a once idyllic place. Brent gives us a very accurate description of the crime and some information of later investigations. However, the ghost only makes an appearance in one chapter and is fleeting to the author. He relates in his book of the ghost:

> *While I stood perfectly motionless, waiting for some recognition of my appeal, the figure advanced slowly in a direct line from the wall, leaving the shadow, and stopped before me and not 20 feet away from me. I saw at once that it was somebody I had never seen before. When in the light without even a weed to obstruct my vision, as soon as he stopped, I called, "Speak or I will fire!" The figure never once turned its head directly toward me but seemed to fix its look eastward over where the pine-trees broke the clear horizon on the murder-hill. This inert pose was preserved but for a moment, for as quick as the flash of gunpowder it wheeled as upon a pivot and, making one movement as of a man commencing to step out toward the wall, was gone!*

In the spiritualist modality of the time, he would guess that the ghost was actually the father of Isabella and John, appearing because he wanted to bring some cessation to the pain and the agony that the living were still feeling over the crime.

More than anything, Brent's book seems to have been cathartic for him, a labor that helped him come to grips with a terrible act that he could not

comprehend. Whether he really saw a ghost we will never know, but for him, to see the ghost may have helped in some way.

At the time, however, the book drew a general suspicion of the author. People who read the book certainly might have thought it was strange and unusual. Brent himself admits in the book that he was a suspect for a short time in the week after the murder because he had been seen in the forest with a pallet knife and pistol on other occasions. The police quickly dismissed any notion of Brent being the murderer because they knew him to be the tranquil artist that he was. Later, the publishing of his book raised more than one eyebrow, but it all came to naught.

The case went cold, life went on and people forgot about the two innocents slaughtered that June afternoon in Bussey Woods. Eight years went by, and then in 1873, the tragedy resurfaced. A man named Franklin Evans had been arrested for the murder of a young girl named Georgiana Lovering in Northwood, New Hampshire. There were some similarities to the Bussey Woods murders. True crime historian Troy Taylor tells us how the victim was found: "Dr. Hanson bent down to examine the dead girl. A glance at her face, with its bulging eyes, swollen and protruding tongue, and dark bruises at her throat, told him that she had been strangled. Her body had been hideously mutilated. Evans later confessed that he had raped her corpse and then had torn open her belly with his bone-handled knife to get to her uterus. He had also excised her vulva, which he carried away with him and hid under a rock."

Additionally, while in jail awaiting his execution, Evans confessed to several other murders, including the Bussey Woods murders. However, just before he was executed, he recanted only his confession to the Bussey Woods murders.

Over 150 years ago, a family was ruined when two children were murdered before they had even started life, and to this day, the wretched, horrible murders still remain unsolved.

3
THE BOSTON BARREL BUTCHERY

THE LEAVITT ALLEY CASE

At about 3:00 p.m. on November 6, 1872, Stephen McFadden, an employee at the Cambridge Gaslight Works, saw something bobbing in the waters of the Charles River. He left his post and walked down to the river at the end of Ash Street to see what it was. As he approached the object, he could see that it was a wooden barrel, and when it floated closer to him, he was shocked at what he saw protruding from the top of the barrel—a human hand. Almost as suddenly, McFadden noticed another smaller barrel coming down the river and called for William Goldspring, another employee, to go out and pull it in as he secured the first barrel.

McFadden put out a call for the police to come, and before long, Cambridge police officers John Milliken and Moses Child were on the scene. Officer Child tipped the barrel up to see what was in it, and when the gruesome blood and gore met his sight, he immediately deemed this a job for the coroner, put the barrel down and sent word for Dr. W.W. Wellington. At about five o'clock in the evening, Wellington reached the scene. By this time, the remains had been pulled out of the barrel and laid out on some grass. Wellington surveyed the barrels and the remains. He noted that the trunk of a man was lying on the ground, and nearby were the contents of the other barrel: a man's head, arms and legs. The remains were still clothed. Wellington noted the dark suit on the body as well as a hat that had been stuffed in with the rest of the remains. After talking to Officer Child, Wellington also learned there were other items found in the dead man's pockets: a watch, keys, some coins and a piece of scrip.

A coroner's jury was summoned, and the jurors began to examine the body and the contents of the two barrels. They determined that the cause of death was massive blunt force trauma to the head. They guessed that the weapon was probably the blunt side of a hatchet. It was further determined that the victim had been placed on his side, and then his head and limbs were "hacked off in a bungling manner" probably with an axe or hatchet.

When the barrels were more thoroughly examined, some significant clues were found; the police discovered wood shavings, an old worn-out billiard pocket and a piece of brown paper that had "P. Schouller, No. 1049 Washington Street" printed on it.

Dr. Wellington took charge of the remains, and the police took custody of the two barrels, clothing and other items found.

In the next two days, the headlines screamed, "A Boston Horror," "Terrible Mystery in Boston" and "Murder and Mutilation." News accounts gave graphic descriptions of the wounds and itemized the other evidence found in the barrel. Thousands of people were said to have viewed the remains. One of the crowd, George Quigley, knew the man from the barrel and was able to identify him as Abijah Ellis.

Ellis resided at 151 East Dover Street (now East Berkley Street) in Boston. He was a fifty-four-year-old real estate broker and moneylender, and he was last seen the morning of Tuesday, November 5. He was also known to carry large amounts of money to complete his business transactions. Immediately, the police surmised that the motive was robbery.

Boston police chief Edward H. Savage and his detectives took over the investigation when it was learned that Ellis was a citizen of Boston and that the murder probably occurred in Boston as well. The Cambridge police transferred all evidence over to the Boston police.

Early on, detectives jumped on the one big clue they had: the piece of brown paper that had "P. Schouller, No. 1049 Washington Street" printed on it. They traced it to the billiard table factory of Peter Schouller located at 1049 Washington Street in Boston. Police quickly learned that a man by the name of Leavitt Alley who owned a delivery service and a stable was in the habit of removing the wood shavings from the manufacturing of billiard tables, putting them in barrels and bringing them to his stable over on Hunneman Street (now Melnea Cass Boulevard) and using them for bedding for his horses.

Alley was later described by the newspapers as "a large thickset man of medium height and stout, with a head that is partially bald, like that of the man that is supposed to be his victim, and wears a long whisker on

HISTORIC CRIMES IN THE HUB

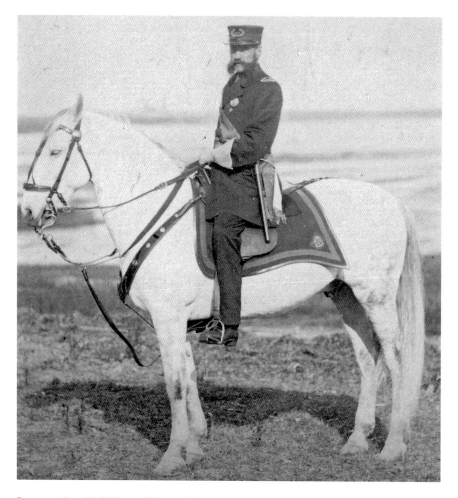

Boston police chief Edward Hartwell Savage. *Image courtesy of Mark W. Pyne.*

his chin, which has evidently been died [*sic*] black although originally of a gray color."

The newspapers also described his demeanor as imperturbable when he was later interviewed by Chief Savage. The chief was made aware of the wood shaving trail that led to Leavitt Alley on the morning of Thursday, November 7—the day after the discovery of the body. It was also learned that Alley was acquainted with Ellis; in fact, Ellis held the mortgage to Alley's house and had been receiving monthly payments from Alley.

That evening, with his two detectives, Charles Skelton and Albion Dearborn, Savage went to the home of Leavitt Alley at 5 Metropolitan Place.

They arrived a little after midnight and knocked on Alley's door. When Alley came to the door, Savage told him they had come to see if he could give any information about the death of the man found in Cambridge. Alley said, "Yes, I had heard of it." Savage then told Alley that he understood that Alley had been in the habit of carrying shavings from Mr. Schouller's. Alley said he had been in the habit of getting shavings from Mr. Schouller's, taking them to his stable and using them for bedding. Alley thought the last time he got shavings was on Monday or Tuesday previous and said he carried the barrels back. The chief then inquired as to who had keys to the stable. Alley replied that he, his son and one of his teamsters had keys. Savage then asked him if he knew of any teams of horses being taken out the night of the murder. Alley said no, but that morning (Thursday) he had found his stable open and one of his horses loose.

Chief Savage wanted to ascertain what Alley had been doing the night of the murder, so he asked him to recount his movements. Alley said he went home from his stable to his house and had supper with his family, which included his son and one of the teamsters who worked for him. He further recounted that at supper his son said a stove had been left out at his delivery stand and ought to be looked after, as it was going to rain. He told his son he was going to look after it and left his house about 7:30 p.m. to do so. He walked the mile or so to his stand to cover the stove, and then he headed back to the house. Alley told the chief that he returned home at about nine o'clock. The chief then asked him what he did the rest of the night, to which Alley replied that his wife was taken sick in the night, and he was up twice to help her, the last time at four o'clock. At five o'clock, he went down to the stable to open it up for the day.

The chief then asked him what he did on November 6, the day after the murder. Alley told him again that at five o'clock, he went down to the stable. After a while, his teamsters came, and Alley harnessed up his team and went back home and had his breakfast. Then he went to his stand and took a package to Court Square, explaining that he had gone through Washington Street, Castle Street, Harrison Avenue, Chauncy Street and Devonshire Street to Court Square but then corrected himself, saying he didn't go to Court Square but went to Haymarket Square to deliver the package. After that, Alley stated that he went to his lawyer Mr. Morse's office and paid some money. He continued, saying that after doing his business, he went back via the same route he came. Savage then asked him if he had ever had any trouble with his stable before. Alley said he had; that he had lost some grain and other things, besides an axe, which had been missing some time.

HISTORIC CRIMES IN THE HUB

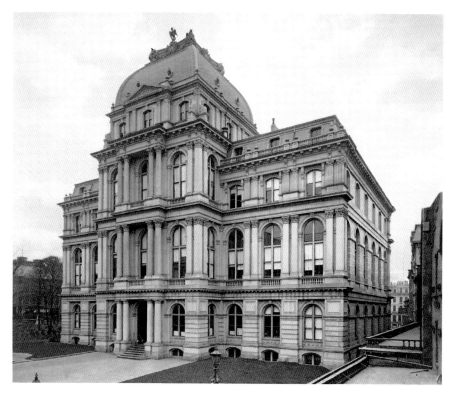

City hall. *Image courtesy of the Boston Public Library.*

Hearing this, the chief asked him if he had an axe. Alley said no. When asked what kind of an axe he had lost, he said it was an old one.

At about one o'clock in the morning, after questioning Alley, the chief and his detectives asked Alley if he could bring them down to his stable on Hunneman Street. He consented and led them to the stable, unlocked the door and brought them inside. There were no lanterns, but Alley had some candles and showed the officers his stable by candlelight. The candlelight proved not to be bright enough, and the chief asked Alley if they could come back the next morning. Alley replied that they could, and the chief told him to meet him at his office at city hall the next morning at nine o'clock.

On Friday morning, Alley came to the chief's office, arriving at 9:00 a.m. The chief directed Detective Skelton to take Alley over to Cambridge where the body and barrels were being kept and show them to Alley. After viewing the body and the barrels, Alley was brought back to talk to the chief about what he had seen. Immediately after he returned, the chief asked him if he had been out to Cambridge. Alley said he had and that he

had seen the body of Mr. Ellis and the barrels. Surprisingly, Alley admitted that the larger barrel had been his, but he was not positive about the other. Alley remained at the chief's office until four-thirty that afternoon, and in the meantime, the officers were engaged in investigating the case.

Two key witnesses had been found: Franklin Ramsell, a teamster, and Ellen Kelley, a housewife who lived near Alley's stable.

Ramsell told police that he had been driving his team toward Boston across the Mill Dam (now Beacon Street) toward Parker Street (now Brookline Avenue). Ahead, he saw another wagon approaching. As Ramsell came closer, he noticed the wagon had stopped at the sluiceway, a water gate on the dam used to regulate the water. (The location today would probably be in the vicinity of the intersection of Mountfort Street and Beacon Street being several hundred yards or so from the Charles River because of all of the landfill that has been placed there over the last century and a half.) He passed the wagon and its driver and continued up the Mill Dam. Shortly thereafter, Ramsell took a right onto Parker Street. Almost as soon as he had taken that turn, he was overtaken and passed by that same wagon.

He specifically noted some interesting things. He would later say in court:

> *I met a wagon containing two barrels; as I turned into Parker Street the same team passed me again, but without the barrels; and when I looked*

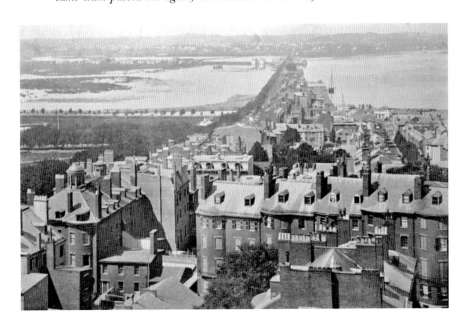

Mill Dam (Beacon Street), 1858. *Image courtesy of the Bostonian Society.*

HISTORIC CRIMES IN THE HUB

> back I could not see them on the road; didn't notice the wagon particularly, but my attention was directed to the appearance of the horse, that he was very sick with the prevailing distemper; couldn't swear to the man; the barrels were lying upon the bilge, mostly covered with an old carpet; one of the barrels was new and the other old; didn't notice the size.

The two barrels Ramsell had seen in the wagon when approaching the sluiceway were now gone. He turned and looked back to see if they had been left behind—they were not. This implied that the barrels had been thrown into the sluiceway, which drained out into the Charles River. Later, a police officer would go down to the sluiceway and find wood shavings on the ground nearby and marks on the rails that seemed to indicate something of great weight had been pushed over them into the sluiceway.

The two other things he noticed that day were important as well. He saw an old carpet partially covering the barrels and that the horse was sick with distemper, as many were that year. It would turn out that Alley had such a carpet in his wagon, and one of his horses matched the description Ramsell gave to police.

The other witness, Ellen Kelley, lived at 6 Spring Lane, just thirty feet from Alley's stable. On Friday night, November 8, detectives knocked on her door and asked her if she had seen or heard anything on the day or evening of the murder on November 5. She replied that she certainly had. She told police that when she was passing in the alleyway in back of the stable at about 7:00 p.m. she heard someone yell, "God d--n you!" She continued, telling police that at about 8:00 p.m. she went for a pail of water and heard voices in the stable and the sounds of someone rolling barrels and that there had been a light on in the stable until 10:00 p.m.

On Thursday the seventh, the police did a much more thorough search of the stable. In one of the stalls there was a pile of manure. When removed, it was revealed that there were over two hundred drops of blood on the lower wall and floor.

That same day, the chief asked Alley to remove his shirt and pants, and it was found that he had blood on his undershirt and his drawers. A search of his house revealed more bloodstained clothing. When asked about the bloody stable and clothing, Alley simply replied that it was blood from one of his horse's nostrils. The sick horse was bleeding from the nose, and the blood was sprayed all over the floor, wall and Alley.

The chief also learned from one of Alley's teamsters that there had been a red hatchet in the stable before the murder. However, once the stable and

Alley's home were searched, all police came up with was an old axe. The chief must have wondered, where was the red hatchet? Alley's teamster went further, telling the police it was a new hatchet and that the previous one had been stolen when the stable was broken into weeks before. Hearing this information, Chief Savage quickly dispatched all his detectives to every hardware store in the area, hoping that one of them would remember Alley buying that red hatchet. A little shoe leather paid off, and detectives were able to locate Albert Gardner, the proprietor of a hardware store on Washington Street, which was not far from Alley's stable. Gardner told police that Alley had purchased such a hatchet on October 1. He couldn't remember what color it was but could only remember it had a defect on the handle.

After a while, Savage brought Alley back to his office and shut the door. He had Alley sit down and then pulled up a chair and slowly leaned over, looking Alley straight in the eye. Pausing for a moment, the chief quietly asked, "What would you say if one of your acquaintances should say he saw you on Charles Street Wednesday morning [in the vicinity of the Mill Dam]?"

Alley said, "I have not been on Charles Street for a long time."

The chief then said, "What would you say if a man would testify that he met you on the Mill Dam, on Wednesday morning, with some barrels in your wagon and afterwards saw you without them?"

Alley said, "I was not on the Mill Dam."

The chief pressed him further, saying, "Mr. Alley, what would you say if one of your own workmen would testify that you had a new axe, painted red, in your barn on the Monday before the murder and that it was used to drive a rivet?"

Alley retorted, "I remember it; but it was the same axe you found in the yard." (It was not.)

Then the chief hammered down on Alley, asking, "Mr. Alley, what would you say if a witness should testify that blood was seen on your shirt-bosom?"

Alley restated, "It came from a horse!"

Trying his hardest to break Alley, the chief played his ace and asked, "Mr. Alley, what would you say if chemists, who have examined the clothing you had on, should say there was a large amount of human blood upon them?"

Alley replied, "I have accounted for that before."

Unable to break Leavitt Alley, Chief Savage advised him that he would have to be taken into custody and that he should probably seek legal counsel. Alley was locked up, but in the space of just a few hours, all of Boston's collective attention would be on one thing and one thing only—the "Great Fire of Boston."

HISTORIC CRIMES IN THE HUB

Great Fire panorama, 1872. *Image courtesy of the Bostonian Society.*

The Great Fire of Boston started at the corner of Kingston and Summer Streets in the downtown area of Boston at about 7:00 p.m. on November 9. It is not known for sure what caused the fire, but many have speculated that an errant spark from a steam boiler that powered a newly installed elevator may have ignited goods stored near the boiler, thus causing the great conflagration.

It was the most devastating fire in Boston's history. It raged for fifteen hours, causing $73.5 million in damage ($1.5 billion in today's dollars). It destroyed 770 buildings that were stuffed with surplus merchandise and caused the deaths of at least thirty people.

What was left afterward was sixty-five acres of wreckage and ruin. Daily life in Boston came to a grinding halt while fire companies continued to put out small pockets of reemerging fire and the police secured the area from looters and gawkers who had come from all over New England to behold the smoldering ruins.

The trial of Leavitt Alley had to wait. The authorities were able to indict him on December 9, 1872, but his trial would be postponed until February 1873 due to the fire.

The trial began on February 3, 1873. The presiding judges were Justices John Wells and Marcus Morton. The Commonwealth of Massachusetts was represented by Attorney General Charles Train and District Attorney John May. Alley was represented by Gustavus Somersby and Lewis Dabney.

Great Fire, Pearl Street. *Image courtesy of the Trustees of the Boston Public Library/Print Department.*

The trial began when District Attorney May stepped in front of the jury and delivered the opening statement for the prosecution. He indicated to the jury that the prosecution would prove that Leavitt Alley murdered Abijah Ellis when an argument ensued about mortgage money Alley owed Ellis. May went further and told the jury that the prosecution would show that Alley dismembered the body with an axe in his stable and then stuffed the bloody body parts into barrels.

In his narrative, May pointed out to the jury that the prosecution would present several witnesses: one who had seen Alley the morning after the

HISTORIC CRIMES IN THE HUB

Courthouse at Court Square. *Original photograph by Catherine Reusch Daley.*

murder on the Mill Dam where it was thought the body had been thrown into the Charles River, two who would testify to a hatchet bought by Alley that was in the stable and that the hatchet was now missing and, finally, a witness who would testify to overhearing a quarrel in the stables the night of the murder.

Additionally, May asserted that he was going to call medical experts to testify that "the man was killed, in all human probability, by blows from the blunt end of an axe, and by blows struck from behind. On his head are four distinct blows, either of which would have hurried a man into eternity."

Oddly, May did not mention in his opening statement that the prosecution was also going to attempt to prove, through medical evidence, that the blood found on Alley was indeed human blood and not that of a horse.

After concluding his opening statements, May began to call witnesses. His first witnesses were establishing witnesses who told of finding the body and turning it over to police and then of the identification of the body.

Then John Tibbetts, Alley's teamster, took the stand and testified about the hatchet/axe he had seen: "Alley had an axe in the stable, which I saw there a few days before the election; it was a light, new axe and painted red. I should say, [I] haven't seen it since that day, when we used it in mending the harness; on the Friday after the election I looked for it." (The axe found at Alley's house was here presented to him, and he said he'd never seen it.)

Alley's neighbor Ellen Kelley was called to the stand. In her testimony she stated:

> On election night, I went through the alley-way at the back of the stable on my way to Bartlett's bakery. It was about seven o'clock. I heard voices in the stable but nothing that I could distinguish. When I came back, I heard someone say, "God d--n you." There was a light in the stable 'til ten o'clock. About eight o'clock, I went after a pail of water; I heard voices in the stable and heard a noise as if someone was rolling barrels.

Franklin Ramsell was called and told of his activities on the morning of November 6, the day after the murders. He explained to the jury that he started out at about eight o'clock in the morning (which he fixed by stating that he had heard the Brookline Church Bell ring) with his horse and wagon and went into Boston. When he reached the Mill Dam, he said he saw a man who looked like Leavitt Alley with a wagon, sickly black horse and two barrels in the back, both covered by a carpet. He further recounted that when he next saw this man as he passed him on Parker Street, the barrels were gone.

HISTORIC CRIMES IN THE HUB

To corroborate Ramsell, a man named W.S. Richards was called and stated that he had seen Alley on Charles Street, which was near the Mill Dam: "I am acquainted with Alley. [I] saw him on Charles Street, between Beacon and Boylston Streets, on the morning after the election, sometime after seven o'clock. He was driving a dark bay horse, I thought. He was not going very fast. I was walking to my stable in Ashburton Place. [I] didn't see him again that week to my knowledge."

Further corroboration of the barrel dumping was provided by Boston police officer John W. Perry. He stated, "On the Saturday after the election, I found some black walnut and white wood shavings on the Mill Dam Bridge. [I] noticed that the railing was marked as though something heavy had been slipped over; the marks were about three feet apart."

Albert Gardner, the hardware dealer, was sworn in. He described how Alley had purchased the hatchet/axe from him preceding the murder: "I am acquainted with Alley; he came into my shop and purchased an axe. It happened to be the last one of the kind I had, and there was a little defect in it. That was on the evening of October first. When he came in, he said that someone had stolen his old axe. The axe in court is not the one I sold Alley."

The prosecution realized it had a problem here; Ramsell stated that he was at the Mill Dam shortly after 8:00 a.m., but his corroborating witness stated he saw Alley in the area after 7:00 a.m. The prosecution would chalk this up to a mistaken time by Ramsell by pointing out that that he must have heard the "Brookline Bell" at 7:00 a.m. and not 8:00 a.m.

The prosecution then brought up a string of city church bell ringers; all except the bell ringer at the Town Unitarian Church in Brookline stated that they didn't ring their church bells during the weekdays, only on Sundays. The keeper at the Unitarian church told the court that he rang the bell every morning on the hour. This fact seemed to corroborate Franklin Ramsell's previous testimony that he fixed the time of his departure by the "Brookline bell" and could easily have mistaken the seven o'clock bell for the eight o'clock bell.

District Attorney May brought up men who knew the victim and testified that he was wealthy and known to carry large amounts of cash on his person. Then May introduced three witnesses who testified that, the day after the murder, Leavitt Alley paid on debts that he owed them—one in the amount of fifty-one dollars and two in the amount of fifty dollars. Here, the obvious inference was that Alley took the money from Ellis and paid some of his debts the next day.

Next, May called Boston police chief Edward Savage. May led Savage through a detailed recounting of how evidence in the barrel led to Alley, the

subsequent investigation that revealed that there was blood at the scene and on Alley himself and how the police came upon the witnesses who had just testified for the prosecution. Additionally, Savage recalled for the jury the conversations he had with Alley before his arrest in which he explained the blood evidence as having come from a sick horse and not knowing about any hatchet that was in the stable.

Following Savage were his detectives Charles Skelton, Albion Dearborn and James Wood. Skelton told the court that Alley had identified one of the barrels the victim was found in as his. He also gave a description of the search of Alley's house that turned up an old axe in the backyard (the one in the courtroom) and of finding bloody clothing. On the stand, Dearborn stated that Alley had told him that he didn't have an axe, that it had been stolen. Detective Wood's testimony was that Alley had lied to him about the clean white shirt he was wearing on November 8 when interviewed by Wood. Alley said that he had been wearing that shirt since the Sunday before the murder, but when confronted with the bloody shirt found in his house, he admitted that it wasn't the shirt he was wearing at the time of the murders and that it was the bloody shirt.

Next, the medical experts were called to testify. The first to take the stand was Dr. John Foye. He testified that he had been brought to the stable of Leavitt Alley on the morning of Saturday, November 9, and that he examined the bloodstains found on the floor and on the wall of the stable. He testified that at that time the stains appeared to be fresh bloodstains and that there were about two hundred bloodstains in all on both the floor and the wall. He further stated that it appeared that someone had tried to cover the stains by shoveling manure over them. Additionally, he told the court that later that day he was taken to the home of Leavitt Alley and shown the bloody clothing. He remarked, "On the morning of Saturday, I took some twenty spots of blood from clothing which was alleged to be Alley's and also took blood from boards. On the left leg of the pants was a large spot of blood, and the pants looked as if they had been washed. Blood was also found on the coat and vest, and the clothing was given to Dr. Hayes, who made a microscopic examination of the same."

Dr. Hayes took the stand and testified that he had received the clothing and the blood from the stable. He cut bloody pieces of clothing out and examined them under his microscope and came to the conclusion that it was human blood and not that of a horse. Dr. Hayes testified, "On the sleeve of the undershirt I found blood which was human blood, which

I compared with the blood of a horse. I compared this blood with the blood of Mr. Ellis and found no difference in the blood on the undershirt and on Mr. Ellis's drawers." He based his conclusion on the fact that the corpuscles in the blood of a horse are much smaller than in a human body.

After Dr. Hayes came Dr. John Hildreth, the doctor who had conducted the autopsy of Abijah Ellis. Dr. Hildreth explained that "the head was severed from the body. The legs were completely severed from the trunk midway between the hip and knee. The skin was normal in color and presented a black and blue appearance around the lacerations. Over the cheekbone on the left side of the face was an abrasion of about an inch. On the head were four wounds."

Dr. Hildreth then produced the skull of Abijah Ellis in open court to the gasps of onlookers and explained, "The wound on the left side of the head shows that in all probability the blow was given from behind. This wound was about three inches in length, extending through to the bone. The nature of the wound was not such as to indicate that the wound was made by some sharp instrument. It would be difficult to say as to whether the wounds were made with a round or an angular instrument, but in all probability they were made by an angular instrument."

Dr. Reginald Fitz was the last to take the stand. He said he examined the stomach and determined that the murder occurred during digestion within three hours after food had been taken. It had been determined earlier through the testimony of Mary Tuck, who ran a boardinghouse near where Ellis lived and where he took his meals, that he'd eaten a supper of bread and milk between 6:00 and 7:00 p.m. the night of the murder, so this put the murder somewhere between 7:00 and 10:00 p.m. on November 5, which coincided with the testimony of witness Ellen Kelley.

The prosecution wrapped up its case, and Judge Wells asked the defense if it was ready to present its case. The counsel for the prisoner replied in the affirmative and requested that all the witnesses for the prosecution be cleared from the courtroom. The request was assented to and the witnesses removed.

Lewis Stackpole Dabney, co-counsel for the defense, rose and gave his opening statement. He immediately went on the attack, decrying the near defamatory treatment of the press toward his client and stating that the newspapers exaggerated the case by "dressing up what they heard for the public prints." Then he claimed that the government had knowingly left out evidence that would have exonerated his client.

Dabney then carried out the expected and usual procedure of the defense council explaining to the jury what the definition of murder was, the dangers of circumstantial evidence and the need for proof beyond a reasonable doubt in order to convict.

In a clear and succinct manner, he outlined what his case would be. He called into question many of the prosecution's facts.

Did Ramsell see Alley at the Mill Dam shortly after seven o'clock in the morning? Dabney claimed that the prosecution's church bell evidence proved nothing about the time he left. The bell rings at both 7:00 and 8:00 a.m.; therefore, he could have been at the Mill Dam a full hour after Alley was seen in the area.

What time did the murder occur? Mrs. Kelley heard angry voices in the stable around 7:00 p.m., and Mary Tuck stated that Ellis had eaten between 6:00 and 7:00 p.m., but Dr. Fitz stated that the victim was killed within three hours of having eaten.

Was it really human blood on Leavitt Alley's clothes? The prosecution's argument was based on the fact that horse blood corpuscles are smaller than human corpuscles. Dabney countered:

> *All the blood that they had to work with was, they tell us, dried before they got it. When the blood dries, the corpuscles shrivel and shrink. Before these gentlemen can measure them, they have to be soaked and swollen again. If the liquid used to soak them with is too light, they don't swell to their original size; if it is too heavy, they become larger. We are dealing all the time with thousandths of an inch. If you soak dry human blood in too light a liquid, you may not swell the corpuscles so as to make them any bigger than horse corpuscles. You might then mistake human for horse blood. If you use too heavy a liquid for soaking horse blood, you might swell the corpuscles big enough to measure as much as the corpuscles of human blood. How do we know that this has not been done with the blood on the prisoner's clothes? How do we know that exactly the right liquid was used? We only have the oaths of these experts that such is their opinion.*

Were the barrels thrown from the Mill Dam at 7:00 in the morning? Dabney questioned the timeline of witnesses who saw floating barrels in the Charles River:

> *Are we to infer that the barrels containing the body of Ellis, after being thrown into the river, floated and waited patiently about the spot where*

they were thrown in from half-past seven in the morning until half-past two in the afternoon, so as to give a chance to as many witnesses as possible to look at them, and come here and tell about it, and that they then dashed off up the river against the wind at a rate of speed which brought them a distance of three or four miles to the gasworks in about half an hour?

Was the motive for the murder Alley's inability to pay Ellis? Dabney would state, "This man at the bar is no pauper. I am going to prove that he had money enough to pay all he ever owed Ellis six times over."

Dabney concluded by saying, "These things, Mr. Foreman and gentlemen, are what we expect to prove to you. I have prepared no studied conclusion or exhortation to close my address to you. I think it will be your pleasant duty, after hearing the evidence which we shall offer, to render your verdict of not guilty, which will restore Leavitt Alley rejoicing to a happy family and friends, and the news of which will carry joy to the heart of his aged mother at her home among the hills of New Hampshire."

The first action of the defense was to recall the hardware store owner Albert Gardner. He was asked if he could remember the color of the handle on the hatchet that he sold Alley (the reputed missing murder weapon), which was reported by others to have been red. Gardner stated, "The handle might have been red, but I thought it was dark blue or green; it was the last axe I had in the store and weighed from four to four and a half pounds. [I] am not willing to swear that the handle was painted red."

Next, two witnesses, Daniel Mahan and George MacIntosh, were called. Both claimed to have seen Alley the day after the murder and testified that he had no blood on his clothing that they noticed.

Dabney then proceeded to call thirteen witnesses—eleven from New Hampshire and two from Massachusetts—to testify in lockstep and almost verbatim that Leavitt Alley "had a reputation as an honest, peaceable, quiet and inoffensive man and is very good."

Interspersed among the character witnesses were several witnesses who testified about Alley making loans to certain individuals. However, the judge stopped the defense from asking them to speculate on Alley's financial condition because he deemed the guesses incompetent as reliable information.

Alley's two daughters were called to the stand to establish that he had come home the night of the murder just after 8:00 p.m. and that he did not leave the house until after 7:00 the next morning, thus narrowly providing him an

alibi for the time of the murder and excluding him from being at the Mill Dam shortly after 7:00 a.m. as Ramsell testified. However, if one examines the answers Alley gave to the police, this testimony is inconsistent on two points. One, Alley himself said he got home around 9:00 p.m., and two, he said he went to open up the stable at 5:00 a.m. and then went home to breakfast.

Professor Henry Mitchell of the Coast Survey was called to testify about the rate that the barrels would have floated down the river. He stated that "if an object was placed in the river at the sluiceway on an ordinary tide, the least possible time it could reach the gasworks would be four hours and twenty-four minutes, according to my observation; it would be within the range of possibility for a barrel on a strong tide to float to the gasworks from the sluiceway in three hours."

This was far less than the eight hours that the prosecution argued the barrel took to get down the river. But upon cross-examination, the attorney general was able to get Professor Mitchell to admit, "A barrel thrown into the water at the sluiceway an hour and a half before low tide, and half or nearly submerged, would probably float around among the flats in the basin and remain until the flood tide lifted it."

John George Wilkins, veterinary surgeon for Alley, took the stand and testified that he was with Alley in September and that during the process of bleeding one of the horses both he and Alley were sprayed with the horse's blood. He was of the opinion the blood found on Alley's clothing and in the stable was that very same blood.

Next came the medical experts. The first was Dr. Charles Jackson, who styled himself as an analytical and consulting chemist and state assayer for the commonwealth. Jackson told the jury, "There is no way to tell how long blood has been in a place after it has dried." Then he further damaged the prosecution's case by stating, "There is no method known to science which can determine whether the corpuscles after being swelled are of their original size; I know of no means, and none are recorded in scientific authorities, of determining the difference between the dried blood of man and that of Mammalia. This is settled by the highest authorities."

James F. Babcock, an analytical chemist and professor of chemistry at the Massachusetts College of Pharmacy, followed Jackson. He stated that "after blood has once dried up, it is impossible to tell how long it had been there" and further echoed Jackson's testimony by stating, "After blood is dried, it would be impossible to perfectly restore the corpuscles to their normal condition. I don't know of any authority which tells the way to distinguish between the dried blood of man and that of Mammalia. There

is no standard of measure to tell the difference between the dried blood of man and that of the Mammalia."

Then, to close his case, Dabney brought up several witnesses to testify that they had seen Alley at different times during the day of and the day after the murder, thus strengthening his alibi.

The defense rested.

In rebuttal, the prosecution called Dr. Hayes. He was asked the condition of the blood he saw on the floor at the stable, and he answered, "Some of the blood I took on the ninth of November was coagulated soft blood. It was flexible and could easily be bent. After being in my possession a month the blood dried. Some of the stains I found were dry, but the majority of the blood was soft."

Then he was asked by the prosecution, "From your experience, Dr. Hayes, can you tell whether the blood had been there one week or six weeks?"

Dr. Hayes replied, "I think I can. In my opinion, this was fresh blood which had been in the barn only a few days."

The prosecution recalled the police detectives to counter some of the alibi testimony, saying that some of the witnesses at the time of the murders had told them they had not seen Alley, whereas now in court they were telling a different story.

The prosecution then rested its case.

Closing arguments were made by both sides, and Judge Wells made the charge to the jury. He concluded his remarks shortly before 6:00 p.m., and the jury retired to decide on its verdict.

At precisely 9:45 p.m., the prisoner was placed at the bar, and the members of the jury entered and took their seats on the panel. The court directed the clerk to inquire if they had agreed on their verdict.

The clerk looked at the jury foreman and said, "Mr. Foreman, have you agreed on a verdict?"

The foreman answered, "We have."

The clerk looked at the prisoner and said, "Leavitt Alley! Hold up your right hand!...Foreman, look at the prisoner."

The clerk then stoically asked, "What say you, Mr. Foreman? Is Leavitt Alley, the prisoner at the bar, guilty or not guilty?"

The foreman answered directly, "Not guilty!"

Then, as to confirm the verdict, the clerk asked, "Gentlemen of the jury, hearken to your verdict as the court has recorded it. You, upon your oaths, do say that Leavitt Alley, the prisoner at the bar, is not guilty. So you say, Mr. Foreman? So, gentlemen, you all say?"

All answered in the affirmative—Leavitt Alley was now a free man!

4
THE BOSTON SKULL CRACKER

THE THOMAS PIPER CASE

On December 6, 1873, the readers of the Boston newspapers learned of a horrible crime. The previous night, a young Boston woman named Bridget Landregan, known for her beauty and charm, had been brutally bludgeoned to death not far from Upham's Corner in Dorchester.

Just after 9:00 p.m., the residents of Hancock Street heard the screams of a woman. When one or two stepped out into the darkness to see what the commotion was, they were met by the sight of a man wearing a cape and a tall silk hat leaning over a prostrate form in front of the blacksmith shop. Almost as soon as the doors opened, the man stood erect, vaulted over an adjacent stone wall and bolted toward the railroad tracks.

Before long, a small crowd began to form around the victim. She was still alive, lying in a pool of blood moaning and groaning in agony. One person in the crowd called for the "watch," and soon Sergeant John Collyer from Station Two was on the scene.

Beholding the horror that lay before him, he quickly asked, "Did anyone see what happened?"

One of the witnesses said, "She was lying here where she is now. A man [was] bending over her, but he ran away."

Another bystander offered, "That's right, he went that way," pointing in the direction that the attacker ran and then said, "He ran down across the Boston, Hartford and Erie Railroad tracks."

Collyer then ordered the men standing there to "scatter. See if you can find him. Don't worry; there will be more members of the watch here directly."

HISTORIC CRIMES IN THE HUB

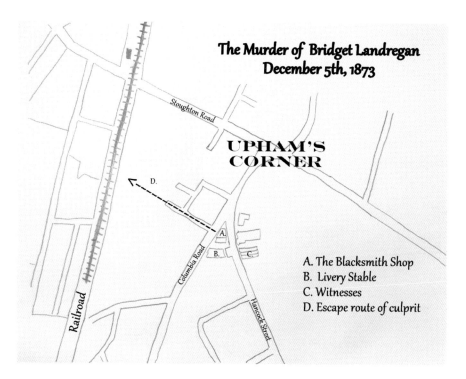

Map of Upham's Corner area—site of the murder of Bridget Landregan. *Map by author.*

As several bystanders ran out and began to search for the villain, Collyer procured a ladder as a makeshift stretcher and moved the girl off the street into the stables of Hall and Wilson farther down on Hancock Street. Once in the stables, Collyer attempted to communicate with the girl, asking her who she was. All she could do, with a look of terror on her face, was move her lips. She struggled to speak and then had a spasm and went limp. When the doctors arrived shortly thereafter, she was pronounced dead.

As the doctors and police were looking over the victim, police officer C.H. Simpson entered and said, "Look what I found on top of the stone wall just above where the woman was lying!" He then handed Collyer a short, thick, blood-spattered piece of wood that had a whittled handle and a brass tip—certainly a weapon created to have the most damaging effect on a skull.

Collyer took the cudgel given to him by Officer Simpson and went back to the station and sent a notification to Boston police chief Edward H. Savage. Savage then notified every station in Boston to arrest anyone who appeared to be strange or suspicious.

MURDER & MAYHEM IN BOSTON

The girl was identified as Bridget Landregan of Bellevue Avenue. She came from Ireland, was in her early twenties and worked as a domestic. According to author Curt Norris, in his book, *Little-Known Mysteries of New England*, "Public feeling ran high for her, although the girl held a humble position in the community, her beauty, like that of the famous Agnes Surriage of Revolutionary times, had surmounted all social barriers."

According to Norris, Savage put Detective Albion P. Dearborn on the case, and Dearborn went to work straight away interviewing witnesses. He was able to get a description of the murderer. Many told Dearborn that he appeared to be about twenty-five and wore a tall silk hat and cape. When Dearborn sat down to interview a young boy—the son of a local barber, who had seen the fiend flee—he said something a little different.

Dearborn asked of him, "You saw him?"

"Yes, I did," the boy replied. "He ran off as soon as he saw me, but I saw the silk hat and he wore the clothes of a gentleman. He ran like a sailor though."

"Like a sailor?"

"Sure. Didn't you ever see a sailor run? They run with a roll. And that wasn't all. Every now and then, he had to stop to catch his breath."

This last remark by the boy would stick in Dearborn's mind and become helpful in the days to come.

After interviewing all the witnesses, Dearborn set out to find out if Bridget had any suitors. He found she had many. He had to determine where each one was at the time of the murder. One by one, the men gave their alibis, and they all checked out. Dearborn had one more name on the list, and that name was Thomas Cahill. When he looked into Cahill's background, it seemed like he'd hit pay dirt.

Norris tells us that Cahill "had been deeply in love with the victim. Further, he'd been heard to swear that if he didn't win her hand, no man would." In addition to this, Norris relates that Dearborn "learned that Cahill worked in Roxbury and had been in Dorchester on the night of the murder. He checked the man's employer and learned that Cahill was on the high seas aboard the Cunard liner *Marathon*. He'd turned all of his savings into cash and sailed for Ireland."

Dearborn also discovered that Cahill had boarded the ship after having had a farewell drink with Thomas Blinn, Bridget's uncle.

A cable was sent to Ireland to hold Cahill when his ship landed. This was done, and then another cable was sent with instructions to send him back to Boston. The Irish authorities complied.

HISTORIC CRIMES IN THE HUB

Cahill looked very good as a suspect for the murder of Bridget Landregan, but Dearborn had his doubts. During his investigation, he confided to Chief Savage that he learned where the murder weapon came from. It had been sawed off the shaft of a carriage. What's more, he had been able to find the carriage that it had come from. The carriage belonged to the Piper family, who lived on Mt. Pleasant Avenue in Dorchester.

Thomas Piper, one of the sons living at the address, closely matched the description of the escaping attacker. When Dearborn did some further digging, he found that the young man had a "kidney condition" that would cause him to stop to catch his breath if he ran any distance. Also, Dearborn would find that he had spent a good amount of time at sea, which might account for the witness's observation that he ran like a sailor.

Savage ordered Dearborn to bring Piper in for questioning. When confronted with the murder weapon, he claimed that he knew nothing of it. When asked about the murder, he said he was at a building fire that happened that same night. He further stated that he heard about the murder the next morning. With no real evidence against him, Piper was released. But something wasn't right—Dearborn and several of the other detectives didn't believe his story.

Thomas Cahill was brought back from Ireland in chains. He was arraigned and would wait months in jail for his trial.

On July 1, 1874, there was another bloody attack on a woman, but this time she would survive. Marie Thomas, a prostitute who went by the name Mary Tynan, picked up a customer on Lagrange Street, had a couple of drinks with him and then brought him back to her room at 34 Oxford Street in "a known prominent assignation quarter of the city." The customer awoke during the night, grabbed a hammer that was lying on a nearby table and tried to bash her skull in. After several brutal strikes, he was sure she was dead and jumped out the window and escaped. The same story was reported in many of the newspapers: "They found the girl lying in her bed weltering in her blood, with which the sheets were covered. She was in a semi-conscious condition, and appeared desirous of speaking, but was prevented by paralysis of the tongue, resulting from injuries she had received. She had received nine severe scalp wounds, four of which perforated the skull, and brain matter was oozing out from two of the fractures."

Her boyfriend, Dana S. Colby, was immediately suspected. Police surmised that he found someone in Mary's room and hit her over the head with a hammer—just like the one that was missing from his tool kit that he used for his job as a wood turner.

MURDER & MAYHEM IN BOSTON

Deer Island almshouse. *Image courtesy of the Trustees of the Boston Public Library/Print Department.*

Mary did slowly recover. Colby seemed genuinely concerned and visited her at City Hospital every day. However, when police questioned her, she refused to identify her attacker. The newspapers speculated that Colby had proposed marriage—if she wouldn't inform on him. The truth was that her attacker was not Colby, and she probably didn't want it known publicly that she was a prostitute. Either way, within a year, Mary was declared insane and was sent to "an asylum on the island," probably the home for paupers on Deer Island in Boston Harbor.

In the intervening year, there were more murders in Boston than usual.

On October 31, 1874, Catherine Harris of 70 B Street, South Boston, was found stabbed to death. Her husband would later be convicted of the crime.

On December 6, 1874, Edward Noonan, a man only known by the papers found on him, was discovered by a police officer in a gutter at the corner of Hanover and Court Streets. It was believed that he had been beaten and robbed by a group of four "roughs." The murder was never solved.

On March 22, 1875, a young woman named Margaret Bingham was found in her cellar by her mother at their home at 97 Webster Street in East Boston. The scene was later described in the *Boston Globe*: "The body was

drenched in blood and so covered with coal dust and gravel as to be hardly recognizable, the face being terribly scratched and the nose badly damaged by a blow from some iron instrument. Her entire body was bruised from head to foot, and around her neck the prints of fingers were plainly visible. The mouth of the murdered woman was found filled with gravel and one pebble the size of a walnut had been forced down as far as the epiglottis."

It turned out that a man named George Pemberton committed the crime. His defense was that he was drunk and could not remember committing it. He was convicted and hanged seven months later.

On April 8, 1875, the body of Mary Dennehy was found in pieces laying on the railroad tracks near Savin Hill in the Dorchester section of Boston. Upon further investigation, it was found that her husband, John, along with a Julia McCarthy, had thrown her body there after he had killed her. John fled the city, and it seems that Julia was later released because there is no record of her having been tried for the crime.

Then on Sunday, May 23, 1875, all of Boston was shocked by the horrible murder of a beautiful little five-year-old girl in the belfry of a church in the South End. Her name was Mabel Young.

Mabel had just attended Sabbath school at the Warren Avenue Baptist Church; it was just before 3:30 p.m. Her aunt, Miss Augusta Hobbs, arrived to take the child home. As she was leading Mabel home by the hand, she was waylaid by a fellow church member in the vestibule of the church and fell into conversation. She loosened her grip on the child's hand as her attention focused on what was being said. Mabel wandered back into the schoolroom and asked Mrs. Carrie A. Roundy, the children's Sabbath school teacher, if she could take out a book called *Real Stories*. Although books were not to be taken out on Sundays, it appears that Mrs. Roundy had a soft spot for the adorable little girl and checked out her book anyway. From there, Mabel walked out of sight.

A few minutes later, Miss Hobbs came in frantically searching for Mabel; others joined in. Everyone was calling her name, checking in every room and every closet. She was nowhere to be found. The search party decided to expand its search to the outer neighborhood. The only person who remained was the church sexton busily setting up chairs for a meeting that was to occur that night.

Some of the searchers were still within sight and earshot of the church. Then a flurry of pigeons emptied out of the belfry en masse. Just as everyone in the street was looking up to see the avian exodus, a piercing scream cut through the air like a knife. It came from inside the belfry tower, and those who heard it sprinted back to the church.

MURDER & MAYHEM IN BOSTON

Warren Avenue Baptist Church. *Image courtesy of the Bostonian Society.*

Once in the church, they got to the tower door and found it locked; the door just wouldn't budge. Then they began to look for the sexton, who had all the keys to the building. He emerged from a side door, and Harry Hineman, one of the Sabbath school teachers, told him that they had heard screams coming from the belfry and keys were needed to get up there. The sexton replied that he didn't have the keys and was severely reprimanded by the frustrated Hineman. Then Hineman asked him if he'd seen any stranger around the church, to which the sexton answered that he'd seen three boys skulking about. The sexton then said, "She ain't up there…I'll go look for the key." More screams came from the belfry, and the sexton returned to an angry group

HISTORIC CRIMES IN THE HUB

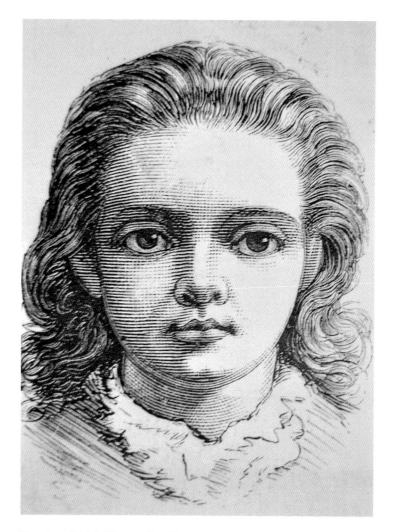

Drawing of Mabel Young. *From* Frank Leslie's Illustrated News.

with an all-consuming purpose—to get into the belfry. The sexton nervously made more excuses, saying, "She can't be up there; the door has been locked since last winter!" He then told the group that he had looked for the key and could not find it. At this dire moment, the decision was made to break down the door, which was done in short order. At the first level of the tower, a newspaper was found, and underneath was a pool of blood. When some nearby loose floorboards were removed, a bloody baseball bat was found. The door to the next level of the tower was also locked, but that was soon breached, and some of the men ascended the ladder into the belfry and there found the girl.

MURDER & MAYHEM IN BOSTON

The scene was described by the *Boston Post*: "Lying in a corner, among heaps of dust and clouds of cobwebs, was a child, Mabel Young, her blood flowing from a terrible wound at the base of her skull. While her once fair and pleasing countenance was now little less than a bruised and bleeding mass, at intervals of two to five minutes she would seem to rally and then utter loud and heartrending shrieks and then would relapse into insensibility."

Mabel was moved to a home on nearby West Brookline Street. There she languished for a little over a day, going in and out of consciousness, and then on Monday, May 24, she succumbed to her wounds and died.

Almost immediately after the girl was found, the sexton was suspected. The police on scene called Chief Edward Savage to come to the church. When he arrived, he asked to talk to the sexton, and when the sexton was brought to him, the look on Savage's face must have been one of simultaneous recognition and realization as he came eyeball to eyeball with Thomas Piper, a former suspect in the Landregan case. Savage stepped up to Piper and noticed the ring of keys on his belt and ordered Piper to turn them over. Piper quickly complied. Then Savage took the keys, tried each of them in the belfry tower door and one worked. Piper was put under arrest.

Thomas Cahill, who had been sitting in jail awaiting trial for the murder of Bridget Landregan, was discharged from custody. The police realized they had the wrong man for the Landregan case and released him on June 2, 1875. The City of Boston would later pay for his passage back to Ireland.

On May 25, at about 1:00 p.m., Thomas Piper was arraigned and charged using the overly complicated, repetitive, legalistic scramble that is best left to lawyers:

> *Thomas W. Piper, with force and arms in and upon one Mabel H. Young, feloniously, willfully and with malice of aforethought, did make an assault, and that he, the said Thomas W. Piper, then and there with a certain wooden club which he the said Thomas W. Piper, in both hands then and there held, her said Mabel H. Young, in and upon the head of said Mabel H. Young, then and there feloniously, willfully and of malice of aforethought did strike, giving unto her, the said Mabel H. Young, then and there, with the wooden club, by the stroke aforesaid, in the manner aforesaid, in and upon the head of her, the said Mabel H. Young, one mortal wound, of the length of three inches and depth of one inch, of which said mortal wound she, Mabel H. Young, from said twenty-third day of May to the twenty-fourth day of May at Boston aforesaid did languish, and did die.*

HISTORIC CRIMES IN THE HUB

A drawing of Thomas Piper in the belfry. *From* Frank Leslie's Illustrated News.

After the arraignment, Piper was taken back to jail. At about 3:00 p.m., Detective Dearborn entered the cell with Detective John F. Ham. They told Piper that he was going to take a ride and that he was going to be taken to 50 East Chester Park, the home of the Young family, to view the body of Mabel.

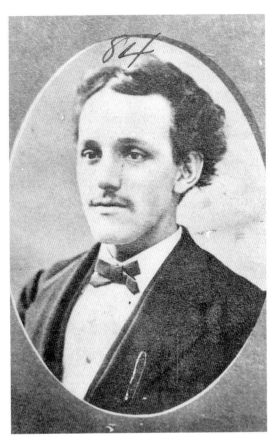

Thomas Piper portrait. *Image courtesy of Historical and Special Collections, Harvard Law School Library.*

Mabel's lifeless body lay in the parlor. It was kept on ice in preparation for the autopsy that was soon to be performed. Many of the members of the Young family surrounded the girl in deep mourning. They had prepared themselves the best they could to look upon the face of the man who had done this ghastly deed to their innocent little girl. A knock came at the door, and in walked Piper with a policeman on either side—the room went silent. Piper was shuffled over to the corpse. It was reported that Detective Dearborn broke the silence and said, "Mr. Piper, you are not obliged to answer any questions that may be here asked of you, if you do not wish to do so." Piper nodded that he understood.

Dearborn then said, "Have you ever seen this child before?"

Piper, not appearing to be nervous or upset, just gazed at the girl for what seemed an inordinate amount of time and then looked up to Dearborn and said, "I don't know that I ever have."

Dearborn then quickly shot back, "Didn't you tell me when I arrested you that you had spoken to her at Sunday school last Sunday afternoon?"

Piper came back with, "No, I didn't tell you that—but I did tell you that I might have seen her there and spoke to her, but I can't remember if I did or not."

The detective quickly realized that viewing the victim was not going to shake Piper, so they decided to take him back to the scene of the crime: the Warren Avenue Baptist Church.

HISTORIC CRIMES IN THE HUB

East Chester Park, now Massachusetts Avenue. *Image courtesy of the Bostonian Society.*

Oddly, Piper seemed more emotional when he arrived at the church. He was somewhat reluctant to get out of the carriage and go into the church but eventually did. He entered the building and looked around as he walked with his police escort from room to room. As he was led through the library, it was reported that he picked up a book called the *Cord and the Creese*, one of those dime novels that many in the public felt was corrupting the youth, and said that he had been reading that book the previous Sunday afternoon.

Piper was then led to the door of the belfry. Detective Dearborn said, "Come, let us go up into the belfry."

Piper replied, "I don't care about going up there," stopping at the entryway.

The detectives told him he had no choice; taking him by the arms, they began to ascend the stairs. Piper now showed his nervousness and began to tremble noticeably.

Piper was brought to the spot where there were still bloodstains on the floor. When the detectives pointed them out, he just told them that the blood could have been that of one of the birds that had been nesting in the belfry. Not able to get anything further from their prisoner, the detectives brought him back to the jail.

In the days that followed, detectives continued their investigation and found further information pointing to Piper's guilt. Contrary to Piper's story, several people had been in the belfry with Piper within the six months he had stated that there hadn't been anyone up there. A grocer even came forward saying that Piper had sold him some pigeons with freshly wrung necks from the belfry just three days before the murder.

An unidentified witness told police that Piper approached Mabel, apparently bothering her, and then later sat and stared at her all during church services that day.

Detectives also learned that young Frances Leland told her parents that Piper had tried to lure her up into the belfry weeks before Mabel was murdered.

Also, the talk on the street was that Piper read "dirty books" and had a bottle of whiskey and opium mixture hidden beneath the pews that he drank on Sundays.

A witness living near the church had seen a man matching Piper's description jumping from the first window of the belfry twelve feet to the ground and then quickly enter the church around the time Mabel had disappeared.

Due to the heinous nature of the crime, the police believed that there were many people in Boston who wanted to do Piper harm. So he was brought to city hall and given a special cell to await trial.

After seven months, Piper went to trial in December 1875. The trial only lasted a few days; the case was mainly circumstantial. On the final day, both sides made their closing arguments, the judge gave his charge to the jury and the jury went out to render a verdict, but there would be no verdict. The jury was at a stalemate, which resulted in a hung jury and a mistrial. Piper was taken back to his cell, where he tried to commit suicide by slashing his wrists. A guard found him, and his life was saved at the last moment. After the suicide attempt, he was put on twenty-four-hour watch.

The government quickly regrouped, and the second trial took place on January 31, 1876. This time there was a verdict, and it was guilty. Later, an execution date of May 26, 1876, was set.

After all the legal avenues were exhausted, Piper realized his fate was sealed and made a full confession, which was printed in newspapers all

over the country. In a final conversation with his lawyer, E.P. Brown, Brown indicated that there were a lot of inconsistencies in Piper's story and that he thought he had been lying.

He asked Piper if there was anything else he wanted to say, stating, "If you have anything that you want to tell me now that is true, I will hear it, but if not, I must bid you goodbye and leave you."

Piper replied, "Mr. Brown, I will tell you the whole truth. I killed the little girl."

Brown then asked, "How did you do it?"

Piper answered by saying:

> *I took the bat from the lower room, before or about the beginning of school, to kill somebody. At that time I carried it up into the auditorium, but during the session of Sunday school took it from the auditorium and carried it to the belfry. After the close of school, I came downstairs and opened the doors. Then I went up again at that time I sent away the boys that were playing in the vestibule. After the boys had gone out, I was still in the vestibule; the little girl came upstairs and I induced her to go up with me into the belfry. There I struck her two or three times, and she fell where the blood was found. Then I picked her up and carried the body to the place where it was found.*

Brown then asked if that was all he had to confess and was surprised when Piper replied, "No, sir; I killed Bridget Landregan."

Before Brown could ask how he had killed Bridget Landregan, Piper launched into his next confession:

> *On the night of the affair, I started out with two of my brothers to go to church. After we had got [a] little way, I told them I did not feel well and that I would go back. I left them and walked back alone. Afterward I went into a place where they sold opium. I got some and then went and got some whiskey. I put them together and drank them. I then went back to my house and went downstairs. I took a saw and sawed off the piece of shaft that was found afterward. After I had cut off the piece of shaft I went out, walked around some and hid the piece under the fence. Soon an alarm of fire was rung. I went to the fire and then came back with my brother and stood at the corner of Cotting and Stoughton Streets. While I was there, I saw Dr. Eddy pass along. And I also saw a woman on the other side of the street. Immediately, my brother and I went into the house, and I said, "I guess I'll go to bed." I went down to the kitchen pretending I was going to bed, instead of doing that I*

The skull of Mabel Young. *Image courtesy of the Harvard Medical School.*

went out the back door. I got the club and started after the woman I had seen. I followed her along and overtook her near Glover's Corner. As there were people about there at the time, I followed her down until we got to Columbia Street. Then I was so near her she looked and saw me. I struck her immediately; she fell down, and I struck her again. While I was stooping over the body, I saw a man coming, so I started up and ran away. I got over the fence and started running for the railroad track.

HISTORIC CRIMES IN THE HUB

Brown asked him again if that was all he had to confess, to which Piper replied, "No, I assaulted Mary Tyner" and then proceeded to tell of the bloody attack:

> *I was sexton of the church at the time. I was downtown, in the evening, and near Lagrange Street I met this girl Mary Tyner* [actually Tynan]. *She spoke to me, and we had a little chat together. I invited her to go into a saloon and she did. After we had some refreshments, I went home with her and remained for some time. In the course of the night, I awoke and found that she was asleep. I saw that I could get out by either a front or back window, and so I took up something in the shape of a hammer and struck her several blows so as to smash her head in. I then left the house and went up to the church, where I spent the rest of the night.*

On May 26, 1876, there were two executions in Massachusetts: Thomas Piper at the Charles Street Jail in Boston and Samuel Frost, for killing his brother in-law, at the Summer Street Jail in Worcester.

Frost's execution was horribly bungled. The length of rope given him was too long, and the drop nearly severed his head from the body save some ligaments that still held the body to the head. It was noted in the newspapers that blood gushed out of his neck in every direction and that many in the crowd of 250 fainted at the sight of the carnage.

The end of Thomas Piper's life wasn't as sensational. In fact, it was so routine that it only got a few lines in the newspapers. Piper was now a man ready to meet his maker. He had confessed all and felt that he had been forgiven for his crimes. He spent the days before his execution in prayer with his minister the Reverend Dr. Eddy. It was said that he slept soundly the night before his execution, rose at about 4:00 a.m., ate a good breakfast and dressed himself.

He remained calm and collected right up until 10:00 a.m., when he was escorted to the gallows by Sheriff John M. Clark. After the singing of some hymns and a few words from his minister, the death warrant was read by the sheriff. Piper's arms and legs were pinioned and then the noose affixed and the hood placed over his head. The signal was given, and the trapdoor flew open. Piper dropped, his neck snapped and he was dispatched to eternity. There was stark silence in the moments afterward. The *Boston Post* noted that the sheriff broke the stillness by proclaiming, "And may God in his infinite goodness have mercy on your soul!"

5
SADISTIC YOUTH

THE JESSE POMEROY CASE

Between late 1871 and the fall of 1872, in Chelsea and then South Boston, a string of young boys were lured off by an older boy. They were tied down, violently restrained, subdued and then viciously beaten and maimed. With each successive kidnapping and beating, the severity seemed to increase. Soon, the word spread about these vile and loathsome attacks on the innocence of Chelsea and Boston. In a very short time, the populace of Boston would be in a ferocious rage and ready to find this adolescent monster and hang him from the nearest tree.

It all began on the day after Christmas 1871. On this day, a boy's life was changed forever. Three-year-old Billy Paine was found in an old outhouse near the top of Powder Horn Hill in Chelsea by two men who heard a quiet sobbing coming from within the privy. The two men opened the door to find the boy hanging from a roof beam by a rope tied around his wrists. The sight of the boy must have been both confusing and sickening. He was stripped naked to the waist. His eyes were closed and his flesh blue from the cold. As he twirled from the hanging rope, the men noticed horrible large, raised bruises up and down his back. The men quickly cut the boy down and notified police. Soon, the boy was home with his distressed parents, who had reported him missing earlier in the day. Billy couldn't give much information about his attacker, only that he was a big boy and that he had lured Billy to the privy. Police had very little to go on and must have been befuddled not only by the lack of evidence but also by the cruelty and inhumanity of the act. They surely must have thought, why would someone do this to such an innocent child?

HISTORIC CRIMES IN THE HUB

Powder Horn Hill. *Original photograph by Catherine Reusch Daley.*

"The big boy" would lure and torture seven more victims before his career as the "Boy Torturer" would end with his capture. Two months after Billy Paine's ordeal, on February 21, 1872, a seven-year-old boy named Tracy Hayden stumbled back home to his parents. Like Paine, he had numerous large raised welts all over his back, but this time the attack seemed to be much more brutal. Tracy's face was swollen and bruised, his nose broken and two of his front teeth had been knocked out from the brutal beating administered by the "Boy Tiger," as the newspapers were now calling him. Police were called to the house to find a family in shock and an almost unrecognizable Tracy Hayden. According to author Herold Schechter, in his book *Fiend: The Shocking True Story of America's Youngest Serial Killer*, when they interviewed him, Tracy was only able to say that his attacker was a big boy with brown hair and that the boy lured him up to Powder Horn Hill with the promise of taking him to see some soldiers. Tracy related that the next thing he knew was that the older boy shoved him into an abandoned outhouse, stripped him naked and then stuffed a handkerchief into his mouth. Hayden continued, saying that the boy bound him by both feet and hands to a beam and began to whip him with a stick and threatened to cut off his penis. When the culprit was through, he released Tracy, who was able to make it home to his already worried parents.

On May 20, 1872, eight-year-old Robert Maier was lured into the Boy Tiger's grasp by a promise to go see Barnum's circus. Again, the place of choice was Powder Horn Hill. According to Schechter, as the two were walking up to the hill to go see "Barnum's circus," the hulking brute surprised the eight-year-old by grabbing him and trying to push him into a pond they were passing. The youth broke free and blurted out, "Why did you do that?" At this, he slapped both little Robert's ears simultaneously, stunning him, and then dragged him to an isolated outhouse. He next stripped the clothes off young Robert, pressed a milk cork into the boy's mouth and then lashed him to a post in the outhouse. Frantically laughing and jumping, he flogged the boy with a stick. After a while, the milk cork was removed from Robert's mouth, and according to Schechter, he forced him to say cuss words such as "prick and shit" and also had him say "kiss my ass." Furthermore, Schechter relates, Robert later reported that his attacker became even more excited and began to masturbate through his pants until he climaxed and then after regaining himself quickly let the boy go.

On July 22, 1872, seven-year-old Johnny Balch was peering through the display window of Polley's Toy Shop admiring all the colorful toys and wishing that they were his. Suddenly, he felt a tap on his shoulder and turned

to find a "big boy" behind him. The boy asked Johnny his name and then told him of a man who was willing to give him some money to run an errand for him and said that he would take him to this man. Johnny followed the pied piper to his old hunting ground, Powder Horn Hill. In an outhouse in a deserted brickyard, he set upon the boy, threatening to kill him if he made a sound. Next, he tore off all Johnny's clothes and tied the boy by his wrists from a roof beam as he had done with the other boys. The older boy then began to whip the young boy with his belt about the chest, stomach, buttocks and then the child's genitals. The beating of young Johnny Balch probably again caused his attacker to achieve sexual satisfaction as he had with his last victim. After getting his release, the older boy came back down to earth and untied the boy but threatened to slit his throat if he left the outhouse. Two hours later, a man passing by heard crying coming from the outhouse and discovered a naked and beaten Johnny Balch shriveled up in a ball in the corner of the stinking shack. He was quickly carried to police headquarters, then brought to his parents and later seen by a doctor.

The word went out in the newspapers about the sinister "Boy Torturer," and a $500 reward was offered for the arrest and conviction of this deviant. In July and August, community anger about the crimes—and the failure of the police to solve them—prompted vigilance committees to be formed to find whoever was committing these atrocities. It was at about this time that the crimes suddenly stopped in Chelsea.

Then, on August 17, 1872, a fisherman passing by an abandoned boathouse in South Boston found a half-conscious, bloody and battered boy. The fisherman picked up the boy in his arms and rushed him to the city marshal's office and to medical assistance. The boy was seven-year-old George Pratt. Once he recovered, he astounded police with a sickening tale of utter depravity that was visited upon him. George recounted to police how he was walking along the shore when an older boy approached him and told him that he would give him twenty-five cents to run an errand for him. He told how the strange boy led him to an abandoned boathouse, hit him over the head and stuffed a handkerchief in his mouth. What came next demonstrates the depraved hunger that was growing inside the Boy Torturer and that the need to be more brutal was increasing with each victim. According to Harold Schechter, the attacker began by saying to young George, "You have told three lies and I am going to lick [beat] you three times!" Then he flew into a maniacal rage, pulling his belt off, frantically circling the boy and whipping him with the belt buckle. When this wouldn't do, he began to repeatedly kick the boy in the head, in the

stomach and between the legs. Continuing his sadistic game, he also gouged and scratched young George all over his upper torso and at one point bent over the boy and bit into his cheek, ripping off a piece of flesh like a wolf enjoying a fresh kill. The torture was not over and the Boy Torturer was not done with his prey. Young George began to lose consciousness and then was revived by his tormentor with a slap to the face, after which he insidiously asked, "Know what I am going to do now?" to the delirious youngster. He then produced a long sewing needle and proceeded to jab George in the arm with it, then the chest, into the wound in George's face and then into his groin. The boy screamed out in pain with each puncture. Then he began to pry open one of George's bruised eyelids so that he could jab his needle into the boy's eye. George struggled and managed to slip the grip of the "boy fiend." The last thing that George remembered before he passed out was the searing pain of another chunk of his flesh being ripped off by a human bite as his assailant bit and tore the flesh from his right buttocks.

George would not be the last of the Boy Torturer's victims—there would be three more. They were six-year-old Harry Austin, seven-year-old Joseph Kennedy and five-year-old Robert Gould.

Little Harry Austin was lured underneath a railroad bridge, beaten and stabbed with a pocketknife; then, in a frenzy, the Boy Torturer attempted to cut his penis off but failed due to the dull pocketknife.

After being lured to a remote boathouse, Joseph Kennedy was severely beaten and then ordered to recite the Lord's Prayer, replacing the words with obscenities. Kennedy refused, angering his tormentor, who then slashed him about the body and dragged him down to the marsh and soaked him in salt water to torment the boy even more.

By the time of Robert Gould's attack, the interval between attacks had shortened to just six days. The Boy Torturer's lust for torture and pain was overwhelming him and he was losing control, a trait common to most psychopathic serial killers, but he hadn't killed yet. Had it not been for his capture at this juncture, he most probably would have crossed the line with his next victim or the one after that and become a killer. But he became sloppy—another trait of an escalating psychopath.

On September 17, 1872, Robert Gould was convinced by a "big boy" to follow him to see some soldiers. After walking a great distance, Robert was jumped by the railroad tracks. He was then tied to a pole. Robert was then slashed about the face and neck. According to Schechter, "the Boy Tiger" then in a gleeful way taunted little Robert by saying, "You will never see your mother and father anymore, you stinking bastard, for I am going to kill you!"

and almost at that same moment dropped the knife and ran off, apparently scared off by railroad workers.

Robert would later provide the police with the clue that would bring in the dreaded Boy Torturer. He was able to tell the police that his attacker was a "big bad boy with a funny eye." Robert was asked to elaborate on what the "funny eye" looked like. He responded by describing it as an eye like "a milky," a type of whitish-gray marble known to all boys at the time. To police, the Boy Torturer would now be known as "the boy with the marble eye."

The search was on for the boy with the marble eye. On the morning of September 21, the seventh victim, Joseph Kennedy, was brought by police officer James Bragdon to the Bigelow School on West Fourth Street to try and find "the Boy Fiend." Joseph was brought into classes and made to look around. The nervous boy stated that he did not see his attacker among those in the class. However, the teacher in one of the classes noticed one of his students looking downward and asked him to hold his head up. He did so but held his head so as to keep his eye out of the view of young Kennedy. Kennedy took a look at the boy sitting at the desk and signaled that it wasn't him. Kennedy and the police left for the next classroom.

Later, while Officer Bragdon and Joseph Kennedy were sitting just inside the entrance of Police Station Number Six on Broadway, they noticed a boy who was out on the sidewalk poke his head in the doorway to take a look. All eyes met, and the boy knew that he'd been seen by the two. He quickly popped back out the door and began to walk briskly toward his home just down the street. After a short distance, young Kennedy yelled, "That's him!" After getting a good look at his eye this time, Kennedy shouted, "I know him by his eye!" At this, Officer Bragdon bolted out the station house door, sprinted down the street, grabbed the young miscreant by the collar and hauled him back to the station.

That curious boy at the police station door, as the police would later discover, was Jesse Harding Pomeroy, the same boy who had looked away when the teacher told him to look up previously at the Bigelow School. Police learned that he had just turned thirteen the previous November, and they also found that he had just moved to South Boston from Chelsea with his mother, Ruth, a divorced dressmaker, who had her own shop on West Broadway.

Jesse seems to have been an outcast and a loner. He was a bit overweight and large for his age with a head that appeared too big for his body and an eye with a cataract that made it appear like he had a "milky" marble in his eye socket. Jesse was the subject of schoolyard taunts. Classmates later remembered him as sullen and non-participatory in school or sports after

school. One classmate later recounted that he would just sit on the sidelines and jab his knife into the dirt. In his autobiography later written in prison, Pomeroy tried to depict himself as a mischievous but good boy—on the one hand lighting off firecrackers in school then on the other going to Sunday school. However, there later appeared stories of his darker side from his neighbors. There were stories of him twisting the heads off of his mother's canaries and of him killing and torturing a neighborhood kitten—harbingers of things to come.

As soon as Jesse was locked in a cell, his interrogators set upon him. Bragdon and fellow officer William Martin went at Jesse with full force. Through all the threats and the yelling, Jesse held his own and refused to admit that he was the dreaded Boy Torturer. The officers decided to let him sleep for a while and then woke him in the middle of the night and continued to work him over with more threats. Jesse could no longer withstand the grilling and tearfully admitted that he was indeed the Boy Torturer. The next morning, five of his victims were brought in to identify him, which they all readily did.

With confession in hand, the police went to Judge William G. Forsaith. A short hearing was held, and Jesse was sentenced to serve six years at the House of Reformation at Westborough until he reached the age of majority, at which time he would be released.

The House of Reformation at Westborough, called the Lyman School for Boys, was first established in 1886, replacing the former State Reform School in Westborough, which had been built in 1846. The school contained various workshops and about one thousand square acres of land for use as the school farm. The school was totally self-sufficient, and the boys did all the work whether it was working the farm, doing the laundry or fixing broken furniture. At first, Jesse was given the job of caning the seats of chairs in the chair shop but was subsequently moved to the position of dorm monitor due to problems with his eyes. Not being able to see out of one eye due to a cataract deprives one of depth perception, which is probably needed for the intricate work of caning. Jesse was possibly given the position of dorm monitor because of his size and most likely due to the fact that he was very intimidating to some of the other children in the dorm and able to keep them in line more easily.

Most reports of Jesse's behavior show him to be a perfect reform school student, working hard in both his studies and his work as dorm monitor. However, stories of his sadistic side have crept down to us through the mists of time. According to Schechter, it is said that he excitedly elicited stories of the other boys' beatings and punishment at the hands of the school's

HISTORIC CRIMES IN THE HUB

The ruins of the Lyman School for Boys, Westborough, Massachusetts. *Original photograph by Catherine Reusch Daley.*

disciplinary master. He relished hearing every detail of a whipping or a paddling. Jesse loved nothing more than to hear the screams and the howls of other students fighting, falling down the stairs or getting into any sort of accident. Although he wasn't inflicting pain on anyone, it is safe to say that he must have been constantly fantasizing about it and eking out any semblance thereof in any bit of information he could gain about others experiencing any sort of pain or anguish.

Much later, one of his teachers, Mrs. Laura Clark, would tell an astounding story about Jesse. She related that during the fall of 1873 she and some of her students were working outdoors at the school when she came upon a garden snake. She summoned Jesse over just to help her kill it and get it out of the way. Mrs. Clark described how Jesse pounced on the snake with his rake with savage force. He not only killed the snake instantly but also continued to pound on it over and over again until it was just a mass of blood and flesh pounded into the garden soil. She remarked that Jesse seemed to take extraordinary glee at the act and that she could only stop him by taking hold of his arms and ordering him to stop. After he stopped, it seemed he

was no longer the helpful and polite Jesse she had known but some cold, mindless killing machine absent any kind of conscience.

Jesse's mother, Ruth Ann Pomeroy, never lost faith in her boy's innocence. Like any mother who loved her son, she began to petition and write to all who would hear her. She was a tireless advocate for her son, claiming that he was innocent and that somehow the police had set him up. She wrote again and again to the board of trustees of the school, and finally in January 1872, an investigator for the Board of Charities was assigned to the Pomeroy case. He was charged with checking into Jesse's family and reviewing Jesse's record at Westborough. He went to Jesse's home at 312 Broadway in South Boston and interviewed Jesse's mother and brother and found nothing amiss and that they were hardworking and honest people. When he reviewed Jesse's record at Westborough, he found nothing short of exemplary. Jesse had been a model inmate and had actually gone above and beyond the call of duty in his good behavior. The investigator found two examples this: one in which Jesse had reported two other boys who were plotting an escape and the other where he did not take part in a major escape of over eighty boys from the school on May 5, 1873. The investigator submitted his report to the superintendent of the Westborough State School recommending leniency for Jesse and an early release. As a result, Jesse was released from the Westborough State Reform School on February 6, 1874.

On March 18, 1874, ten-year-old Katie Curran was getting ready to go to school and found that she needed a new notebook. She informed her mother of this and was given some money to go down the street to Tobin's store to get one. She skipped out the front door of the family's residence at about 8:00 a.m., never to return again. When she failed to come home, her parents made a frantic search of the neighborhood and then alerted police. No mention was made of the disappearance in the local papers until April 9, when a classified ad was placed in the *Boston Globe* by the city's mayor, Samuel C. Cobb, and city council. It read: "Five Hundred Dollar Reward: In accordance with an order of the City Council, a reward of Five Hundred Dollars is hereby offered for the detection and conviction of the person or persons who on the 18th ultimo abducted from Broadway South Boston, KATIE MARY CURRAN, aged about 10 years, the daughter of John and Mary Curran, residing in South Boston."

No one ever answered the ad, and Katie remained missing.

Just thirteen days after the reward was offered for Katie, the body of a small boy was found horribly mutilated on Savin Hill Beach in Dorchester

HISTORIC CRIMES IN THE HUB

Modern Savin Hill Beach, site of the murder of Horace Millen. *Original photograph by Catherine Reusch Daley.*

in an old clambake pit. The boy's name was Horace Millen, and he was only four years old. The *Boston Globe* described the body when found as

> *lying within a circle of stones piled up for a clam bake. The throat was cut from ear to ear, an ugly stab had completely put out the left eye, a deep wound had severed the jugular vein, and subsequent investigation exposed the horrible fact that eighteen stab wounds formed a circle about three inches in diameter around the breast, had been made with some instrument like an awl, or a remarkably slender knife blade, and that, with a view to severing an artery, the left testicle had been extracted and a stab inflicted, penetrating the groin to a considerable depth.*

At the scene were two sets of tracks in the marsh mud leading to the body, apparently those of a larger boy and a smaller boy. But only one set led away from the scene—that of the larger boy.

According to the notes of Detective James Rodney Wood, the detectives went back to the station and had a conference with Chief Savage. Wood states that Savage said, "Well there's a strange resemblance about this thing to that young scoundrel we've got in the reformatory. He used to have a

MURDER & MAYHEM IN BOSTON

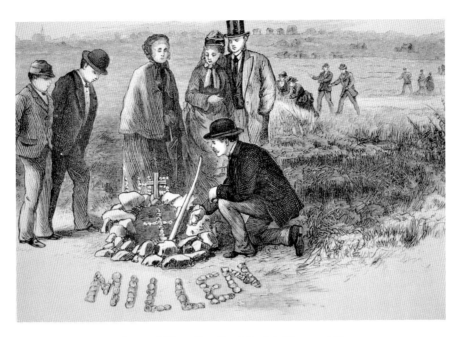

Site of the murder of Horace Millen. *From* Frank Leslie's Illustrated News.

mania for taking boys, slashing them about the face with a knife and tying them up…if that fellow wasn't in the reformatory I should say it was the work of young Pomeroy."

Wood tells us that an Officer Quinn then told the chief, "But he isn't in the reformatory; he's left it!"

Savage reportedly replied, "But you surely must be mistaken?"

Quinn retorted, "No, sir, he's out!"

It wasn't long before the police were on Jesse Pomeroy's doorstep. At about 10:00 p.m., just as Jesse was about to go to bed, a knock came at the door of 312 Broadway. Officers Samuel Lucas and Thomas Adams met Mrs. Pomeroy at the door and had her call Jesse down. The officers asked Jesse as to his whereabouts during the day. Jesse gave his long rambling answer. As he told the police about his travels during the day, they noticed that he had scratch marks on his face and that there were mud stains on the bottom edges of his pants and on his shoes. Unsatisfied with his story and suspicious of the scratches and mud stains, the police informed Mrs. Pomeroy that they were taking Jesse back to the station to question him further. Mrs. Pomeroy argued with the officers, reluctant to let them take her son away. She was told that he would soon be returned to her. With this, Jesse exclaimed, "Don't fret,

HISTORIC CRIMES IN THE HUB

Ma, I didn't do nothing!" as he was taken away breathing his last breath of freedom.

Brought to Station Six, Jesse was quickly surrounded by a group of officers and the coroner who had just examined Horace Millen's remains. Badgered by the officers, he was asked to repeat his story again and again. Jesse recounted for them how he awoke at about 6:00 a.m. and then went to the store to help his brother open up. He further stated that at about 7:30 a.m. he went into the city proper to pick up the newspapers for his brother's newsstand and delivery business and returned an hour later. Jesse explained that he stayed at the store with his brother until about 11:30 a.m., when he went home for lunch. After

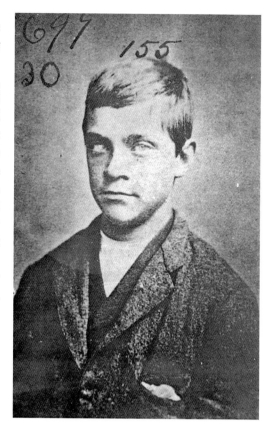

Jesse Pomeroy mug shot. *Image courtesy of Historical and Special Collections, Harvard Law School Library.*

lunch, Jesse told officers, he decided to go take a walk in the city until it was time to pick up his newspapers for the evening delivery at about 2:30 p.m. He told of walking around near the Common and Tremont Street but could not give any details of what he saw or specifics about the area. It became clear to police that Jesse had not been in the city when he couldn't tell them about the major roadwork being done along the route he claimed he took through the city. The officers pressed Jesse further and made him remove his clothes and shoes. The shoes showed evidence of mud very much like the marsh mud they had followed the tracks through. Also found was a bit of marsh grass jammed in the crevasse between the shoe and the sole. Jesse's shirt had what looked like a smudge of blood on it, and upon further inspection, Jesse showed scratches about his neck and on his hand. When investigators found he had a knife, it was retrieved

from his home and brought to the station. It, too, showed signs of what looked like blood and mud from the marsh.

The next morning, police surrounded the scene and began their investigation. The sets of footprints were still there. An astute officer noticed that the prints of the older boy were very clear and came up with the idea of making a mold of them using plaster. Before long, casts were made of the shoe treads. As soon as the plaster was dry, it became noticeable that one of the shoes had a unique imperfection that only one other shoe in the world could have. Jesse's shoes were compared to the mold, and the same imperfection was evident on the bottom of Jesse's shoe. The police now had definite physical evidence that Jesse was, in fact, at the scene.

At about noon, the detectives headed back to Station Six, where Jesse was being held. They gave their report of their findings to the chief of police, Edward Savage, who was waiting there for them. At the conclusion of the briefing, the chief ordered his men to go down to the cells and retrieve Jesse and bring him into the office for more questioning. The officers roused Jesse from his sleep and escorted him upstairs to the waiting Savage. Jesse was asked about his previous crimes and why he had tortured those boys. Jesse's only response was, "I don't know. I couldn't help myself." Then Savage asked him to recount the events of his day on the day of the Millen murder once again. After completing his now well-rehearsed story, Savage informed Jesse that he was now under arrest for the murder of Horace Millen, to which Jesse uttered, "You can't prove anything." Possibly irate at the cocky response from the youngster, Chief Savage responded by saying, "Well then, if you didn't kill Horace Millen, then I suppose you won't mind going out to Waterman's funeral establishment and looking at the body." The cockiness quickly faded, and Jesse responded by squeaking out, "I don't want to go." Jesse was quickly snatched up by the officers, thrown into a waiting carriage and taken to Waterman's. There lay the ghastly sight of the body of Horace Millen on a table about to be embalmed. "I don't want to see him…you can't make me!" Jesse screeched as he was dragged in to view the horribly mutilated four-year-old laying lifeless on the embalmer's table.

According to Detective James Rodney Wood, "Pomeroy hung back and, when pushed forward, he turned his head away so that his blind eye was directed upon the corpse, for he was blind in one eye…I took him by the ears and forced him to look."

Wood then shouted, "Do you see that, boy?" and then "Did you do it?" followed by "Did you kill him?" which came even louder.

Jesse, trembling on the edge of collapse, finally gave in and replied, "I guess I did."

Then the question came quick and sharp from Wood: "What did you do it for?"

Jesse replied, "I don't know…something made me." Having given the officers what they wanted, Jesse now pleaded, "Take me out of here; I don't want to stay here." In the carriage on the way back to Station Six, seeming genuinely contrite, Jesse said, "I am sorry I did it; please don't tell my mother."

Once back at the station, Jesse was returned to his cell and the officers, happy with the morning's work, decided to leave for lunch, leaving instructions with the captain not to let anyone talk to the boy.

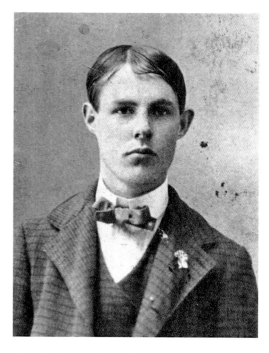

Detective Rodney Wood. *Image courtesy of Historical and Special Collections, Harvard Law School Library.*

After returning from lunch, the officers sat down with Jesse and gave him a pencil and paper and then instructed him to write out his confession in full. Jesse stared at the paper, looked up to the officers and exclaimed, "A written statement! What for?" Jesse further proclaimed, "I never told you I killed Horace Millen. It's all a lie. I didn't kill him, and I'm innocent. I want to go home." Flabbergasted, the officers looked at one another, and one of them shouted, "You told us you killed him!" Jesse smugly retorted, "I never told you such a thing."

Frustrated with their young prisoner, the officers clapped him back in his cell. Later, they found that the captain on duty, Henry Dyer, against instruction, had let someone in to see the boy while they were at lunch. Dyer explained that he felt compelled to let the visitor in due to his status as a board member of the state reformatory. The man in question was one Stephen G. Deblois. Apparently, Deblois told Jesse he was his friend and that he didn't believe that he was guilty, that the case against him was only circumstantial and not to talk to the police anymore. The next day, Jesse's

mother retained two attorneys, and Jesse would stick to his story that he didn't murder Horace Millen.

A coroner's inquest into the murder of Horace Millen was held from April 24, 1874, to April 28, 1874. After a jury of ten heard all the evidence relating to the case, it issued a statement on the last day of the inquest, which went as follows: "That the said Horace Holden Millen came to his death between the hours of eleven o'clock in the forenoon and five o'clock in the afternoon of Wednesday April 22nd, 1874 from loss of blood and injuries received in the neck and chest, which were produced by some sharp-cutting instrument. And the jury further found, that from the testimony before them, that they have probable cause to believe said murder was committed by Jesse Harding Pomeroy."

Jesse was arraigned on May 1, 1874, and pleaded not guilty and was remanded to the Charles Street Jail without bail to await the grand jury hearings.

One month later in June, after hearing much the same testimony and evidence that the coroner's inquest heard, the grand jury indicted Jesse for the murder of Horace Millen and issued the following statement:

That Jesse Harding Pomeroy, April 22nd 1874, at Boston, in and upon one Horace H. Millen (aged 4 years), feloniously, willfully, and of his malice afore-thought, an assault did make; and that the said Pomeroy with a certain knife, the said Millen in and upon the throat and breast, hands, and belly of said Millen, then and there feloniously, willfully, and with his malice afore-thought did strike, cut, stab, and thrust, giving to the said Millen then and there with the knife aforesaid in and upon the throat, breast, hands and belly of said Millen diverse mortal wounds, of which said Millen of the twenty-second day of April did languish and languishing did live and on the twenty-second day of April at Boston, the said Millen of mortal wounds aforesaid, did die.

Jesse again entered a plea of not guilty, and again he was handed over to the officials at the Charles Street Jail with no bail to await his trial, scheduled to begin in December 1874.

After months of searching for their missing daughter, Katie, John and Mary Curran had probably given up hope that they would ever see her again. Following Jesse's arrest in the Millen murder, police did consider him a suspect in her disappearance and even did a cursory search of his residence at 312 Broadway and his mother's dress shop across the street at 327 Broadway in South Boston, but nothing was found and the Curran case was beginning to fade. In May, Ruth Pomeroy shut down her store at 327

HISTORIC CRIMES IN THE HUB

Broadway due to the slump in business associated with the notoriety of her son's case. A new owner, James Nash, purchased the building with the intent of starting a small grocery store in the space that Pomeroy's dress shop had occupied. Nash contracted two workmen, Charles McGinnis and Patrick O'Connell, to help him renovate the old building. Their first task was to enlarge the basement. In early July, the men began their work. The first thing they noticed was an awful stench. Searching about the basement, they could not find the origin of the odor and proceeded to open windows and doors to air out the space. With a bit of a breeze wafting through the dank area, they began their work, removing a wall and an ash heap and leveling the cellar floor. The newspapers reported that on July 18, Charles McGinnis was hard at work demolishing the wall. Hacking at the wall with his pick, it glanced off the wall and went into the dirt floor and kicked something up. Upon further examination, McGinnis discovered to his horror that it was the crown of a child's skull. McGinnis ran out to get Nash, who in turn summoned the police. After a thorough excavation, the entire decayed remains of a small girl were exhumed from the ash heap in the basement of 327 Broadway. The body was identified as that of Katie Curran by her parents. They could not recognize the body due to its advanced state of decay but they were able to identify the tattered remains of Katie's clothing.

When confronted with the discovery of Katie's body in his mother's dress shop, Jesse, in a very cool, matter-of-fact manner, told police he knew nothing about it. When police informed him that his mother and his brother had been arrested for the murder, he wouldn't budge and continued to resist police inquiries.

In the meantime, an autopsy would be conducted on the remains of the girl. It was hard to determine the exact nature of all the wounds, however, according to Schechter. Doctors were able to determine that Katie probably had her throat cut, her dress and underwear slit open and her abdomen, thighs and genitals severely mutilated.

The next day, Chief Savage had Jesse come into his office and sympathetically informed him that he was going to give him one more chance to tell what he knew about Katie's death in order to clear his mother. Jesse sat for a moment sullen and withdrawn and then looked up at the chief and said, "Well, Mr. Savage, I killed her, but I don't want to say how."

The chief replied, "That just won't do. You must tell me how you killed her."

Jesse gave his confession and even made a little drawing of the layout of the basement to assist in identifying the locations that he had

327 Broadway, South Boston—front door to Ruth Pomeroy's dress shop. *Original photograph by author.*

mentioned. The chief had Jesse write everything he had said down so he could present it to the coroner's inquest, which was scheduled for the next day.

The next day at the coroner's inquest, the chief took the stand and read from Jesse's confession. In his confession, Jesse stated:

> *I opened my mother's store that morning about half past seven o'clock. The girl came in for papers. I told her there was a store downstairs.* [There was no store but a dark cellar.] *She went down to about the middle of the cellar and stood facing Broadway. I followed her, put my arm about her neck, my hand over her mouth, and with my knife cut her throat, holding*

HISTORIC CRIMES IN THE HUB

327 Broadway—where Katie Curran's body was found. *Original photograph by author.*

my knife in my right hand. I then dragged her to behind the water closet, laying her head furthest up the place, and I put some stones and ashes on the body. I took the ashes from the box in the cellar. I had bought the knife before for about twenty-five cents. The knife was taken from me when I was arrested in April last. When I was in the cellar I heard my brother at the outside door which I had locked after the girl came in. I ran upstairs and found him going towards the cellar on Mitchell's part, and he came back. [Pomeroy's shared the building with a jewelry store run by a man named Edward Mitchell.] *Two girls worked in the store for mother. They usually got there about nine o'clock. Mother came later.*

MURDER & MAYHEM IN BOSTON

Brother Charles and I took turns opening the store till about April. My brother and my mother never knew of this affair.

Jesse would be indicted for the murder of Katie Curran in September 1874, but the case was placed on file on December 31, 1874, by request of the attorney general.

Jesse went on trial for the murder of Horace Millen on December 8, 1874, and the trial would last for three days. According to the trial coverage in the newspapers, the government was represented by Attorney General Charles R. Train and District Attorney John W. May. May gave the opening statement in which he described the crime and gave a summary of the evidence that would be presented during the trial. Attorney General Train began the case by presenting a map of the crime scene and the outlying area. George Powers, one of the young boys who found the body, went up to the map and indicated the location as about "a half mile from the railroad and within twelve feet of the waterline." Other witnesses there that day corroborated the testimony of the location and described the condition of Horace Millen's body as they remembered finding it. The police were next to testify about the removing of the body and of the ensuing crime scene investigation in which plaster casts of shoe prints were made. The coroner Ira Allen was next to testify; he described in graphic detail the nature of the wounds found on Horace to the horror of those in the courtroom. The bloodstained, knife-tattered shirt of the young victim was produced to illustrate the wounds previously described. The shirt would later be produced during the trial as Horace's grief-stricken mother took the stand. She recounted the day's events, and when asked to identify the shirt, she broke down and sobbingly acknowledged that indeed it was the shirt that her four-year-old had gone out in that terrible day.

Several witnesses were produced who saw Jesse either leading the boy away or running away from the scene. The confession at Waterman's undertaking establishment was corroborated by several who were there. A physician took the stand to identify the brown stains on Jesse's knife as human blood.

Rufus P. Cook, chaplain of the county jail, also testified that that July, Jesse had freely confessed to him that he had killed Horace—this after confessing to police and then recanting. He submitted Jesse's handwritten version that he had elicited from the young boy after their conversation. Soon after the testimony of Cook, the prosecution rested its case.

HISTORIC CRIMES IN THE HUB

Then came the defense's turn. Senior counsel for the prisoner Charles W. Robinson took the floor and began his opening arguments. From the onset, it was clear that Robinson would use insanity as a defense. He began by summarizing in great detail all of Jesse's crimes, including those of the boys he had tortured. After enumerating each crime, he laid down the basis for his defense and stated that Jesse did not have the capacity to resist the urges that drove him to the deplorable acts. Jesse was not "a responsible being"; he had an "unsound mind" and "should not be found guilty by reason of insanity."

The rest of the defense's case was twofold. The first part was to show the utter atrocity of Jesse's crimes while implicitly asking what sane mind would do such things. The second part was to introduce "insane experts" to testify that Jesse was indeed unbalanced and insane. To further hammer home the horrible nature of the crimes, Robinson put several of the boy victims of Jesse's savagery up on the stand to testify in startling detail on just how Jesse had victimized them. The jurors were certainly aghast at the stories they heard and even more shocked when one of the pitiful little survivors, Robert Gould, took the stand. The mutilating wounds Jesse had inflicted on the boy's face were shockingly evident and drew gasps from the courtroom as he gave his testimony. The stories and the sight of the poor young victims would surely be engrained in the memories of all who attended court that day and gave strong testament to the warped mind of the prisoner sitting in the dock.

In the second part of the defense, the foundation was laid by calling Jesse's mother, Ruth Pomeroy, to the stand to relate a series of illnesses that Jesse had in his early childhood that might have caused his aberrance. Mrs. Pomeroy stated that when Jesse was only three years old he developed an infection that left permanent pockmarks on him, was the cause of the cataract in his eye and caused him to lose a dangerous amount of weight. She further related that in his first year he came down with another affliction in which he was delirious for nearly three days and that caused him to have tremors of the head. She noted that ever since this time he had experienced dizziness, great difficulty sleeping, pains in his eyes and horrible headaches. She added that he was "addicted to dreaming extravagant dreams, which usually haunted him the next day."

The defense, having set the foundation for its insanity defense, introduced two "insane experts," as the newspapers styled them. They were Dr. John E. Tyler, who had been the superintendent of the New Hampshire Asylum for the Insane and McLean Asylum for the Insane outside Boston, and Dr. Clement A. Walker, who had been the superintendent of the Boston Lunatic Hospital since 1851. Both experts' testimonies were essentially the

same. They felt Jesse was insane simply because of the freakish nature of the crimes and the fact that Jesse exhibited no apparent remorse, guilt or sorrow from his actions. However, both experts upon cross-examination admitted that Jesse did know what he was doing was wrong, which fell short of the legal definition of insane, which is that a person is insane and is not responsible for criminal conduct if, at the time of such conduct, as a result of a severe mental disease or defect, he was unable to appreciate the nature and quality or the wrongfulness of his acts.

The prosecution introduced the rebuttal witness to the stand: Dr. George C. Choate, who had served as superintendent of the State Lunatic Asylum at Taunton and established a private asylum just north of New York City. Choate testified that he had met with Jesse twice and stated that Jesse was not insane: "There is no insane temperament or taint of hereditary insanity in the boy." Choate went on to further state that Jesse only had a "weak moral character." Shortly after Choate took the stand, the defense rested its case.

Both defense and prosecution made their closing arguments. Judge Horace Gray charged the jury and sent it out for a verdict. After about five hours of deliberation, the jury returned its verdict. The court was so quiet that a pin could be heard to drop.

The court clerk looked over at the foreman of the jury and said, "Is the prisoner at the bar guilty or not guilty?"

The foreman quickly replied, "Guilty of murder in the first degree," which was immediately followed by gasps and then chatter from the onlookers in the courtroom.

Jesse showed no emotion, almost as if he were totally oblivious to what was taking place. His mother, on the other hand, fell back into her chair with her head in her hands and began weeping uncontrollably. A note was passed to the judge from the jury, and the judge announced that it was a recommendation from the jury that the mandatory death sentence not be carried out owing to Jesse's youth. The judge told the jury that he would forward its recommendation to the governor.

Two months later, on February 20, Jesse was sentenced—"to be hanged by the neck until you are dead." Immediately, the debate began: should the state execute a boy of fourteen? The State of Massachusetts had never executed anyone so young. The battle lines were drawn. Each side began writing letters to the governor and letters to the editors of various newspapers. Each side—one to execute the brute and the other to save the young boy—formed its own committee. Pressure came down from both sides on Governor William Gaston to either commute Jesse's sentence to

HISTORIC CRIMES IN THE HUB

Charlestown State Penitentiary. *Image courtesy of the Trustees of the Boston Public Library/Print Department.*

life in prison or let justice take its course. In the end, Gaston couldn't bear the thought of putting a boy of fourteen to death, and he commuted the sentence to life in prison—but in solitary confinement.

On September 7, 1876, Jesse began his life sentence at the Massachusetts State Prison at Charlestown—a term that would last the next fifty-three years until his transfer to Bridgewater State Farm for the Criminally Insane in 1929. Forty-one of those years would be spent in solitary confinement.

Jesse did not just fade from public view during these years; he was constantly featured in news articles about his latest escape. Every two to three years, articles would appear detailing how Jesse had either tried to dig out of his cell, cut the bars to his cell door or window or remove brick from his cell wall. In one ingenious attempt, Jesse managed to bore through the wall of his cell into a gas line that fed the dim gas lamp outside his cell. With a piece of wire, he drilled a hole in the gas pipe, which he quickly was able to plug. His plan was to ignite the escaping gas and cause an explosion that would blow a hole in the wall and create an

MURDER & MAYHEM IN BOSTON

Jesse Pomeroy (left) leaving Charlestown in 1929. *Image courtesy of the Trustees of the Boston Public Library/Print Department, Leslie Jones Collection.*

avenue for his escape. Jesse set his plan in motion on November 10, 1887. When Jesse ignited the gas leak, his plan to blow a hole in the wall came to naught. It did, however, cause a great explosion but only injured Jesse and caused damage to the upper part of his cell.

In another attempt, a prison guard actually caught Jesse in the cellblock outside his cell. It turned out that he had spent the previous three years cutting through the bars on the bottom of his cell door and had managed to wriggle his way out into the cellblock.

After years in solitary confinement, the escape attempts dwindled, and Jesse began to age and, some might say, mellow. He eventually agreed not to attempt any further escapes. After many calls from the public to alleviate Jesse of his solitary confinement, Massachusetts governor Samuel McCall ordered that Jesse's sentence be commuted from life in solitary confinement to just regular life in prison. Jesse would now be given a regular cell and allowed contact with other prisoners and allowed all other privileges of the rest of the prison population. However, the day he was to be transferred to his new cell, Jesse decided that he was going to push his luck and refuse his commutation and

HISTORIC CRIMES IN THE HUB

declare he should receive a full pardon instead. He refused to work as the other prisoners did and refused to mingle with the other prisoners either. At first, he was punished for this, but the warden decided not to further punish the old man for his obstinacy. After a while, Jesse came around and accepted this commutation and began to mingle with the prison population and do some work. Later, he would even perform in the prison minstrel show and publish poetry in the prison newspaper.

The years went on, and the name Jesse Pomeroy no longer appeared in the newspapers. His notoriety slowly began to fade. He was just an old man in prison. In the summer of 1929, the decision was made to transfer Jesse to Bridgewater State Farm, a more open and healthy situation. Jesse was no longer an escape threat or a threat to anyone. After weeks of protesting the decision, he was forced to pack up his few belongings and take his first ever automobile ride. The story was noted in small articles in the newspapers when Jesse arrived at Bridgewater on August 1, 1929. Three years later, on September 29, 1932, "the Child Fiend," "the Boy Tiger," "the Boston Boogieman" passed away from coronary heart disease after fifty-eight years of imprisonment.

His final wishes were fulfilled—he was cremated and his ashes scattered. There would be no funeral service, no grave or marker for Jesse Harding Pomeroy.

6
THE UNRELENTING COP

THE PRICE-COREY CASE

When Sergeant Thomas Harvey arrived for his shift at 9:00 a.m. at the Division Four Station House on Lagrange Street on the morning of May 31, 1925, it was just like any other morning...until a young boy Harvey knew as a bellboy from the Hotel Hollis down on Tremont Street came bursting through the front doors and into the lobby of the station and screamed, "Something terrible has happened over at Hotel Hollis!" In his article for *True Detective Magazine*, Harvey told that the boy's "face was ghastly, and he was trembling like a poplar leaf in the breeze."

Harvey asked the boy, "What is it?"

Flushed and panting from his race to the police station, the boy puffed out, "It—it looks like murder!"

Harvey called a patrolman to accompany him and took the frightened boy back to the hotel. At the entrance, the detective encountered both the room clerk and the manager, whose name was James Reagan. Both men also appeared wide-eyed and shocked. Reagan quickly directed the detective up to room 406, and it was there he met clustered in the hallway around the door a group of frightened employees and guests.

With all eyes on him, Harvey passed through the crowd into the dimly lit room. There, he found facedown on the bed the body of a woman. Her arms were drawn behind her back and bound together with strips torn from the bedsheets. The disarranged bedding suggested a violent struggle. Harvey looked closer and noticed on her neck dark discoloration and scratch marks. He rolled the body to one side and observed that blood from her mouth

HISTORIC CRIMES IN THE HUB

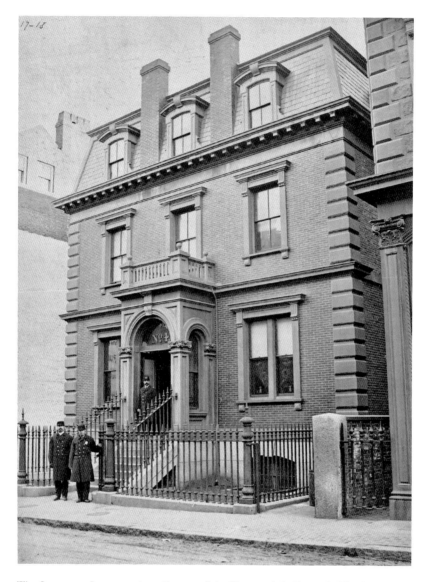

The Lagrange Street station. *Courtesy of the Trustees of the Boston Public Library/ Print Department.*

stained the pillow into which her face was deeply pressed. As he touched the body, he could tell it was cold. It was obvious that she had been dead several hours. And there was no question—she had been murdered.

Harvey had the patrolman secure the scene and went to the lobby to telephone a brief report to the station house. He also told the desk sergeant

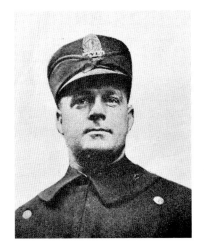

Left: Sergeant Thomas Harvey. *From* Master Detective Magazine.

Below: Hotel Hollis. The arrow indicates the exterior of room 406. *From* Master Detective Magazine.

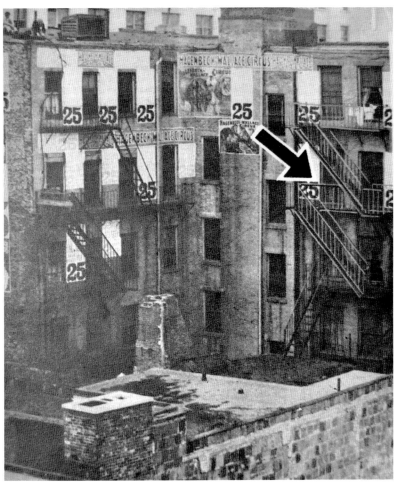

HISTORIC CRIMES IN THE HUB

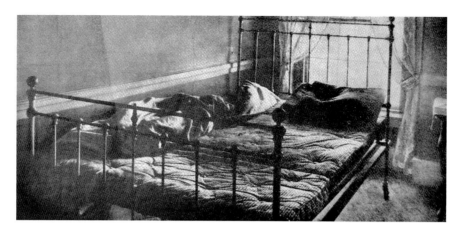

The murder scene. *From* Master Detective Magazine.

to notify Inspector James A. Dennessy, head of the homicide squad. Next, he telephoned the district medical examiner, Dr. Timothy Leary. Soon, other officers were on the scene, and Harvey posted them at the doorways and other exits and ordered all guests in the hotel to remain in their rooms.

After several interviews, it was ascertained that the name of the dead woman was Mae Price. She had been the "Wardrobe Mistress" for a theatrical troupe called the Brown Derby Theatrical Company that had just completed its run in Boston. Harvey learned that Mrs. Price was seen as somewhat of the "mother" of the show and took charge of small sums of money for the younger girls. He also learned that a Jewish boy in the cast had been befriended by her, and he had given her $60 to save for him. In all, it appeared, Mrs. Price had about $200 in her possession from various people. But all that was found in the room was a $5 bill and some small change.

Harvey further learned that Mrs. Price had retired to her room alone around midnight, or shortly thereafter, planning to go to New York with other members of the troupe on the Sunday noon train. When she did not respond to repeated telephone calls to her room that morning, a bellboy was sent up to awaken her. He found the door ajar and looked in. What he saw sent him racing back to the hotel desk with the alarm and then over to the police station.

Soon, Dr. Leary, the medical examiner, was on the scene and began his investigation. In just a few moments, the doctor looked up to Harvey and quipped, "She certainly put up a good fight." In his article, Harvey tells us:

> *When Leary turned the body over, the face and chest showed that the woman had received a fearful beating. Some of the ribs were fractured. Wide bruises*

on the throat and the protruding tongue told that the unfortunate woman had been strangled. After a thorough examination of the marks on the throat, the medical examiner said: "Look for a person with extra-large hands." That was the first real clue we had found. Then he made what seemed to be an important discovery. Under the dead woman's well-manicured fingernails was what appeared to be bits of human skin and dried blood. Laboratory examination later confirmed this.

As the doctor examined the body, Harvey looked for further evidence. He found that everything seemed in place, no drawers had been rifled, her jewelry box was unopened and her bags were intact. However, he did notice one thing and that was that there was what looked like a pay envelope that had been torn open and just left on the floor. Harvey would later find that Mrs. Price had just been paid eighty dollars. It appeared that her pay was missing in addition to the money she had been holding for the other troupe members.

Then another clue was found. Harvey tells us, "Under the bed I saw a partly smoked cigarette." He thought to himself, "This might be a clue. Had the murderer been hiding under the bed while waiting for the moment to strike?"

Harvey began to develop a theory that the attacker gained entry to Mrs. Price's room sometime before her return, hid under the bed and, while waiting, was smoking. When he heard her enter, he put the cigarette out quickly as to not draw attention to his presence in the room. When she was asleep, he subdued her after a fierce fight, suffocated her and took the money.

After talking to everyone who was staying in the hotel, Harvey found two more intriguing bits of evidence. One was that one of the actors, George Arch, who had been occupying room 606 (exactly two floors above Mrs. Price), gave a birthday party for his wife after the performance on the evening of May 30. The man related an odd thing that happened that night but which seemingly had no connection with the murder. He said that when friends were coming up to his room after the theater, he left his door key in the corridor side of the lock so they could get in. When the party broke up and he and his wife were getting ready for bed, he couldn't find the key. He assumed it must have fallen out and that someone had picked it up and turned it in at the hotel desk. When he went down to the desk the next day, no one had turned it in. Harvey would discover that by using a duplicate key to room 606 he was able to open room 406. The other bit of evidence was from Miss Mae Jensen, a vaudeville actress who had a room on the top floor. She told Harvey that around midnight she

was on the way to a friend's room to borrow a razor and was accosted in the corridor by a large, rough-looking man in a brown topcoat. Frightened, she quickly hurried back to her room.

From Dr. Leary's on-the-spot profile, Harvey knew that they were looking for a large man with big hands. The description Miss Jensen gave him of a "large, rough-looking man" seemed to fit. Harvey began to think it was this man, this brute, who took the key from 606, somehow knowing it would open 406, used it and then laid in wait for his victim, Mrs. Price.

After questioning the acting troupe, Harvey came upon another lead. Mrs. Price had eaten at a restaurant on Tremont Street the night of the murder. Harvey went to the restaurant and found that the cashier remembered Mrs. Price and also told Harvey that there was a man who matched the description who seemed to be following her. According to author James A. Kelly, in his chapter on the case in the book *Boston Murders*, the cashier said, "I kept watching him because I didn't like his looks. He'd eaten in the restaurant several times that week, and once in a fit of anger, tore up a five-cent check and threw it in his coffee. When she rose to leave, he got up and stood close to her while she paid her check. He kept eying her pocketbook."

After questioning this witness, Harvey probably came to realize that Mrs. Price's assailant had actually been stalking her that night and got a good look at the money in her pocketbook.

Harvey had a good description of the man they were looking for but not much else. By the close of the week, the case seemed to be going cold, and Harvey decided to take a chance and turn to sources that he had on the other side of the law. He tracked down actor Augustus Vaccaro, who Harvey referred to as a "bum actor who was associated with the underworld."

According to Harvey, he said to Vaccaro, "I've always been on the level with you…give me the office! Give me the office. Who bumped off that woman in Hotel Hollis?" Back in the 1920s, "the office" was slang or vernacular for the truth—the real story.

Vaccaro replied, "Look for that big gorilla that was hanging around the hotel last week."

Then Harvey pointedly asked, "Who is he? Where does he hang out?"

"Don't know anything about him," Vaccaro answered.

"How do you know this gorilla did it?" Harvey demanded.

The actor shot back, "I don't. You wanted the office and I thought of this big gorilla, so I just told you about him."

"Who've you seen this big gorilla talking with?" Harvey persisted. "Come on, you must have seen him speak to somebody. Who?"

MURDER & MAYHEM IN BOSTON

Frank Corey. *From* Crime Detective Magazine.

Finally, Vaccaro gave it up and told Harvey, "Well, I remember one night last week I saw him stop to speak to a man I know. It was in front of the hotel. Benny Perretti was the man he spoke to. Benny was doing a turn at the theater here until Thursday, and now he is playing down in Newport, Rhode Island, and commuting back and forth to Boston."

Harvey quickly brought Benny Perretti in for questioning and found that he didn't know the name of "the big gorilla" either. Perretti did, however, have some other information and told Harvey that this man told him he'd been in prison at Leavenworth Penitentiary and that "they called him the Wop out there." Furthermore, he told Harvey that the "Wop" had escaped from Leavenworth by going through a sewer but was caught a few days later.

A special delivery letter was sent to Leavenworth by police superintendent Michael Crowley requesting any available information and a picture of this individual known as "the Wop." A few days later, a reply came from Leavenworth saying the man known as "the Wop" had served a long sentence for robbery under the name of Frank Corey. Also enclosed was a "Rogues Gallery" portrait of Corey. The photo was shown in an array of other photos to Vaccaro, Perretti, Miss Mae Jensen and the restaurant cashier; they all picked Corey out as the man they had seen.

Now that Harvey had a name, he needed to find a residence. He wrote back to Leavenworth requesting any addresses that Corey had written to while he was in prison there. A few days later, Harvey received a response in which he got three names and addresses: one in Yonkers, New York; a second in Manhattan (New York City); and a third in Worcester, Massachusetts.

In his article Harvey tells us, "I went to Yonkers first and found the person 'The Wop' had written to from Leavenworth was dead. Then I looked up the New York City address. It was on West Forty Second Street and I

HISTORIC CRIMES IN THE HUB

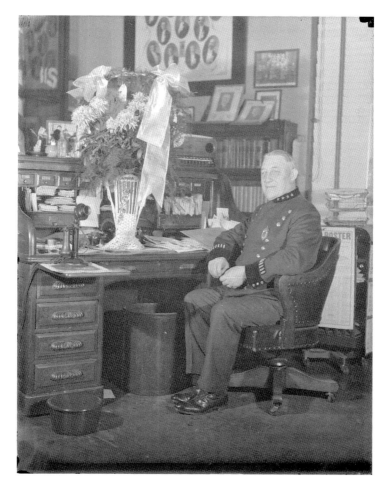

Superintendent Michael Crowley. *Courtesy of the Trustees of the Boston Public Library/Print Department.*

found it was a maternity hospital. No one in this institution knew anything about the man I was hunting for."

Then, with complete thoroughness and resolve, Harvey grabbed a New York City detective and started knocking on doors, checking the number Leavenworth officials had given on every street on the West Side from Thirty-second to Fifty-second. They also were able to get a hold of the letter carriers in the area and ask them if they had ever heard or seen the name Frank Corey, but none of them had.

Finally, Harvey was able to find someone who had seen Corey. He relates that "this was on East Forty-Second Street…when I bumped into a woman

who said she recognized the picture of Corey as a man who had been living next door with a Polish blonde. The woman said the couple were there several years before and that they had 'cleaned out' the landlady and escaped with the loot."

Harvey was also able to learn that Corey had met up with this "Polish blonde" after his release from Leavenworth but was discouraged to find that the house they had been living in had since been razed.

New York seemed to be a bust for Harvey so he decided to check out the last address on his list in Worcester, Massachusetts. The next morning, he arrived in Worcester and went directly to the police department and asked for one of the detectives. Harvey was politely welcomed and brought into the detective's office. Harvey told the detective that the address he was interested in was 934 Grafton Street, and they decided to head out there together.

On the way out to the address, they came upon a motorcycle cop. Knowing that Grafton Street was his beat, the Worcester detective asked him about the address. The officer responded by stating that he was familiar with the address and told the two that the family that lived there were the Krecorians and that they "used the American name Corey." Harvey then took out the mug shot of Corey and showed it to the officer. After taking a look, he told Harvey, "Sure, I know that fellow; that's Frank Corey. I was talking with him this morning. There's sewage draining into the road from the Corey place, and I told them it must be fixed."

Knowing that they had their prey in the crosshairs, the two men came up with a plan. The detective would take Harvey into the house; Harvey would pose as an inspector from the health department and would explain that he needed to take Corey down to the police station to get the sewage complaint taken care of.

When they arrived at the house, they found a "crippled girl," who said her brother Frank Corey had gone into town and would soon return on the trolley car. The officers left the house and then waited down the street for Corey to get off the trolley and walk toward the house. Presently, their quarry was in sight. Harvey tells us, "We started walking along the road and just as we got to the Corey house a big gorilla-like man turned into the yard. It was Frank Corey, the man I had been hunting for more than two weeks."

Corey went along with the sewage complaint ruse and accompanied the detectives to the police department.

When he was safely in the police station, Corey was asked, "When were you in Boston last?"

Realizing the line of questioning wasn't about a sewage leak, Corey responded by saying, "I was never in Boston in my life!"

HISTORIC CRIMES IN THE HUB

Harvey then asked him, "Do you know the Hotel Hollis?"

Corey strongly responded, "Never heard of it," and restated, "I was never in Boston in my life!"

Harvey then told him, "You know the ropes; you don't have to talk if you don't want to. Do you know Benny Perretti?"

"Over in Leavenworth Penitentiary," Corey quietly answered.

Then Harvey showed Corey his mug shot—taken at Leavenworth—and asked him, "Is this your picture?"

Corey even denied this and said, "That's not my picture."

By this time, Harvey must have been very frustrated; he told Corey to stand up, put the cuffs on him and told him he was under arrest for the murder of Mrs. Mae Price.

Harvey went to work building his case against Corey. Shortly after Corey's arrest, Worcester police informed Harvey that Corey had a record with them. It seems that he'd been arrested on a charge of stealing a check and a bracelet. Then, while in police custody, he agreed to make restitution to the plaintiff and was released. With a little digging, Harvey found he had made restitution shortly after Mrs. Price was murdered.

Harvey also found a "Polish boy" in Worcester who told him that Corey had a big roll of bills when he came home early in June and sent the boy to the store to buy a Boston newspaper.

Harvey had Corey stand in a lineup so witnesses could identify him.

The clerk at Hotel Hollis identified Corey as a man who paid $1.50 in advance for room 512 on the night of May 28. The clerk also said he used the name Frank Mulleono and registered again the evening of May 30 but was not assigned a room because he attempted to pay for it with a check for $5.00 written with a pencil and which the room clerk refused to accept.

Miss Jensen identified the prisoner as the man who had accosted and frightened her on the top floor of the hotel the night Mrs. Price was killed and robbed.

Other bits of evidence were added as well. When arrested, Corey had a pack of cigarettes that were the same brand as the partially smoked cigarette found under Mrs. Price's bed.

It was determined that Mrs. Price's attacker was probably severely scratched on the hands and face during the desperate fight she put up to save her life. Harvey would find that a man answering Corey's description had visited a drugstore near the Hotel Hollis the day after the crime to get cream for several severe scratches on his face. Also, Worcester witnesses said Corey's face and hands showed some marks when he came home early in

MURDER & MAYHEM IN BOSTON

The "new" superior court, 1 Pemberton Square. *Original photograph by Catherine Reusch Daley.*

June. And when arrested, he still had marks on his face. When asked about them, he said he cut himself shaving.

Corey would later be indicted and brought to trial for the murder of Mae Price. Then, to the utter astonishment and consternation of Harvey and everyone involved with the case, he was acquitted after a long, drawn-out trial. Harvey would later say of the verdict, "I was amazed and bitterly disappointed, for I felt certain the man was guilty."

Harvey knew that Corey could never be tried again for the murder due to the double jeopardy rights afforded him by the Constitution, but he could look at him for another crime. That crime would be the robbery of Mrs. Price.

Harvey learned that Corey was also a deserter from the army and was able to have him locked up for that. After the trial, he redoubled his efforts to bring Corey down and began to build a case against him for robbery.

During the trial, Harvey had overheard in the courthouse a conversation between two men; they indicated that Corey had gone to a room on Hanover Street after Mrs. Price was murdered. Following the clue from the conversation, he succeeded in locating the room. It was at the Crawford House Annex on Hanover Street. He found that Corey had gone there early in the morning of May 31 with money to pay $2.50 for a room. Corey wasn't

satisfied with the $2.50 room, and after seeing it, he changed to another room for which he paid $3.50.

Harvey also found that Corey had been wearing a brown topcoat when he came into the Crawford House Annex and had left it there. He was able to recover the coat, which would be later identified by Miss Jensen and others as the one he was wearing at Hotel Hollis.

Then, Harvey found that Corey had also stayed at the Boston Tavern on the night of May 31, 1925. The register confirmed that Corey came there the night of May 31 with a female companion and paid six dollars for a room.

Harvey put the evidence together and presented it to the district attorney, who, in turn, presented the evidence to the grand jury, and a secret indictment was returned against Frank Corey charging him with the robbery of Mrs. Price at the Hotel Hollis.

Sergeant Harvey personally went to Fort Devens, where Corey was being held on the desertion charge, with the indictment in hand. Corey was remanded to the officer's custody and brought back to Boston, where he would stand trial once again.

There was a sensational trial covered by all the newspapers, and this time, Corey was found guilty.

The judge who presided over the case, David Lourie, sentenced Frank Corey to life imprisonment. He would state, "Corey robbed Mae Price and brutally strangled her. I am inclined to believe that if the former jury [that] acquitted him of murder heard all the evidence which the government heard in the robbery case, Corey would have been found guilty of murder. Corey is very fortunate in escaping electrocution, which was the just penalty under the law of the commonwealth for the real crime which he committed."

Corey's lawyer would appeal the case, arguing that the sentencing was de facto double jeopardy, but the higher courts upheld the conviction. Frank Corey spent the rest of his life at Charlestown Penitentiary.

7
DEATH COMES TO PRINCE STREET

THE JOSEPH FANTASIA CASE

In 1927, Boston's North End was almost entirely Italian. In the early 1800s, it was an Irish enclave mixed in with a fair-sized Jewish community. North End historian Guild Nichols tells us that the first Italian immigrants came in the 1860s from Genoa and settled in a small area off Fulton Street. Originally, there were only about two hundred new arrivals. However, each year brought more and more immigrants from all over Italy so that, by the 1880s, the ethnic makeup of the North End began to change quite drastically. Of the fifteen thousand Irish who lived here in 1880, barely five thousand remained by 1890. By 1900, the Italian population in the North End was about fourteen thousand people. Over the next twenty years, it would more than double to thirty-seven thousand and, at its peak in 1930, forty-four thousand, all packed into an area less than one square mile in size.

Along with the groups of hardworking, industrious Italians also came the parasitic factions such as the Sicilian Mafia and the Neapolitan Camorra. They made their living off their countrymen through blackmail and extortion.

In the early days, they were known as the "Black Hand" from the insidious "Black Hand letters" that the honest hardworking Italians of the North End received. Typically, a victim would receive a letter threatening bodily harm, kidnapping, arson or murder. In the letter, demands would be made for a specified amount of money to be delivered to a specific place. Commonly, letters would be decorated with threatening symbols like a smoking gun, a hangman's noose, a skull or a knife dripping with blood or piercing a human heart and were, in many instances, signed with a handprint.

HISTORIC CRIMES IN THE HUB

According to true crime historian and author Jay Robert Nash, in his book *World Encyclopedia of Organized Crime*, "The Black Hand practice in the United States disappeared in the mid-1920s after a wave of negative public opinion led organized crime figures to seek more subtle methods of extortion and crime."

It was in this milieu that we find Joseph Fantasia. According to author John Makris, in his chapter on the case in the book *Boston Murders*, "Fantasia, judging from his record was a high-class crook who learned his trade well when he served a lengthy apprenticeship as a member of the Black Hand. When the handwriting of doom began to appear on the wall, he made a fast shift into a loosely organized syndicate handling the flourishing numbers racket in the North End."

Joseph Fantasia was shot down in broad daylight on the streets of the North End by an assassin. But unlike many of the other similar killings of the day—he was not killed in a mafia hit, he was not killed because he was a rat and he was not killed because of some turf war—he was killed because of a woman.

At 4:00 p.m. on June 11, 1927, a call came into Station One on North Street. The caller told the operator that a man had been shot on Prince Street. Quickly, patrol officers and two detectives, Mark Madden and Robert Mooney, were dispatched to the scene.

As they turned from Hanover Street onto Prince Street moving toward the intersection at Salem Street, the detectives noticed a throng of people crowding the narrow roadway. The habitues of Prince Street were out, and they were out in abundance—hanging out the windows, in the doorways, on the sidewalks—so thick the detectives had to push their way through the crush of humanity to get to the shooting victim.

By the time detectives arrived, Fantasia was no longer lying in a pool of his own blood in the gutter with several bullet holes in his back—he was prone in the back seat of a car barely breathing and unconscious. Officer Madden ordered the driver to take Fantasia to City Hospital immediately. As the car was pulling away, Madden motioned toward one of his patrol officers to go with them. The officer jumped up on the running board as the car moved through the crowd.

Just as the car turned the corner onto Salem Street, a man approached Detectives Madden and Mooney; his name was Lewis Smith. Smith told the detectives that it was he who called the station and that he knew where the assailant was. They shuffled him into a patrol car, and he directed them down to the end of Prince Street where around the corner on

The location of the 1927 pastry shop now houses Mike's Pastry. *Original photograph by Catherine Reusch Daley.*

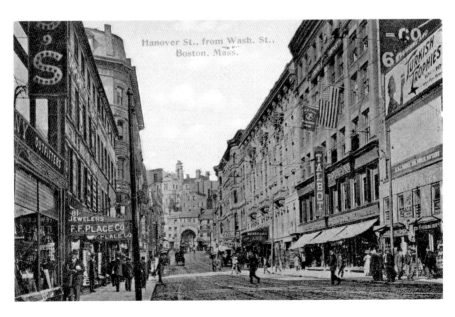

Hanover Street. *Courtesy of the Trustees of the Boston Public Library/Print Department.*

Hanover Street stood a pastry shop (probably the same building that now houses Boston's renowned Mike's Pastry). Smith indicated that they could find their man there.

The patrol car stopped in front of the pastry shop, the doors swung open and the officers barreled in. As they came through the door, there was not a man in sight—so they continued through the curtained partition into the back room. It was there they found an Italian man on the phone requesting that a taxi be sent to pick him up.

As Detective Madden would later tell author John Makris, he took the phone from the man and hung it up and then said, "Never mind the taxi."

Following the police into the establishment, Lewis Smith quickly pointed to the man and said, "That's the man—that's the man who ran away after the shooting. I saw him! I saw him drop a gun near the hydrant."

The man turned out to be young Gangi Cero, a laborer who lived over in the West End of Boston.

"What did you shoot him for?" demanded Madden.

In spitfire Italian, Cero answered him. Madden had no idea what his suspect was saying and glanced with a quizzical look over to the proprietor of the pastry shop, who was standing nearby. The proprietor acted as sort of an interpreter and told the detective that Cero said that he knew nothing of the shooting. He had run into the pastry shop because he wanted to get a taxi. The owner further translated—Cero also said he heard the shooting and saw people running and decided to run with them because he didn't want to be around when police arrived because he had a police record and that while running he'd lost his hat.

At this, Madden said, "From the look of things, he's going to lose more than his hat—put the cuffs on him, Bob."

As Mooney slapped the cuffs on Cero, Madden said, "This time we've got an eyewitness; now let's get back and find that gun."

Going back to the scene of the shooting, the detectives found that there had been a pistol discarded by a nearby hydrant. One of the onlookers picked it up and handed it to another man, thus obliterating any fingerprints that might have been on the gun. An officer at the scene who had taken possession of the weapon showed it to the detectives—it was a .32 Harrington and Richardson Revolver, and every bullet had been fired.

As the officers canvassed the neighborhood, they were able to get information from several other witnesses.

Giovanni DeRosa, who had been across the street from the barbershop at 94 Prince Street where Fantasia emerged before being shot, told

MURDER & MAYHEM IN BOSTON

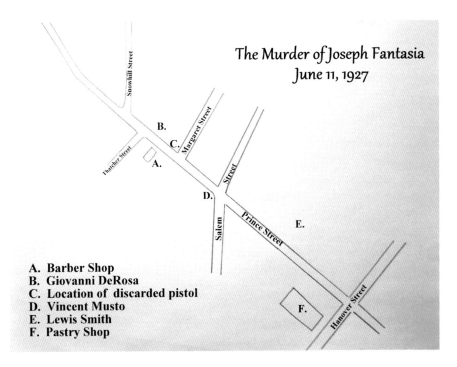

Map of Prince Street area. *Map by author.*

Madden and Mooney that all he had seen was a man running down the street. Furthermore, De Rosa saw the same man throw a gun down near a hydrant. He didn't see the man's face but yelled, "Get him! Get him!" as the culprit ran away. He also told the detectives that he saw a bystander pick up the gun and hand it to another man. When brought face-to-face with Cero, DeRosa couldn't be sure that he was the man he had seen.

Vincent Musto, who had been standing at the corner of Salem and Prince Streets at the time of the shooting, told the detectives that he had seen a man running toward Hanover Street and that the man lost his hat.

Lewis Smith was re-questioned, and he told police that he did not see the shooting but had only heard it. He saw Gangi Cero bolt toward Hanover Street, followed him and saw him duck into the pastry shop. He called the police station from a cigar store across the street.

Detective Madden told author John Makris that he and his partner decided to walk over to the barbershop that Fantasia had been in before he was shot. When they entered, they found the barber sitting alone in his shop "making a poor attempt at reading a newspaper held upside down."

HISTORIC CRIMES IN THE HUB

Prince Street location of barbershop. *Original photograph by Catherine Reusch Daley.*

The corner of Salem and Prince Streets. *Original photograph by Catherine Reusch Daley.*

When detectives pulled the newspaper aside to reveal the "tonsorial artist," they found a familiar face. They were looking down at Patsy Vallerelli, whom they jokingly referred to as "Paddy-wagon" due to his numerous run-ins with the law. They hadn't seen Patsy in quite some time and were surprised to find that he was now a barber.

When questioned by the detectives, Vallerelli made it quite clear that he knew nothing of the shooting and related that Fantasia had been in that day for his late-afternoon shave, explaining that Fantasia was known to get a shave two times a day—once in the morning and once in the late afternoon. He told police that Fantasia walked out of his shop after bestowing upon him a very generous tip. The next thing Vallerelli noticed was that people were running up the street for some reason. He explained that he stepped outside to see what the commotion was and saw Fantasia lying in the gutter.

After Vallerelli recited his story for the two detectives, Madden, in a sarcastic tone, said, "And that's all you know, I suppose?"

Vallerelli sat back in his chair, rubbed his face with his hands and replied, "I'm giving it to you straight, I can't tell you anything I don't know, Madden."

Madden took a seat next to Patsy, leaned over looking him square in the eye and quietly said, "Who was Fantasia with?"

"Nobody, that's the truth; he always came in here alone!" was the blurted reply from the now visibly nervous barber.

Madden slowly stood up, handed Patsy back his newspaper and said, "I'll be back—it wouldn't be a bad idea if you cultivated your memory by then."

Gangi Cero had been taken back to Station One. Inspector Joseph Cavagnaro was called in to do the interrogation. Cavagnaro was an Italian speaker, and as an inspector, he usually dealt with the immigrant population of the North End.

As Cavagnaro was about to go into the interrogation room where Cero had been waiting, he was tapped on the shoulder by one of the officers of the station and informed that Joe Fantasia had died over at City Hospital. The officer told the inspector that he did regain consciousness for a short period but in true gangland form refused to give up his murderer.

Cavagnaro walked into the interrogation room, sat down and told Cero that Fantasia had died at the hospital. Upon hearing the news, Cero winced and became noticeably upset.

Under interrogation, Cero kept to his story: he didn't shoot Joseph Fantasia, he didn't know Fantasia, there was no reason for him to shoot Fantasia and he was mistaken for the killer because he ran. Cero also became quite emotional, pleading with Cavagnaro to be kept from dying "in that

HISTORIC CRIMES IN THE HUB

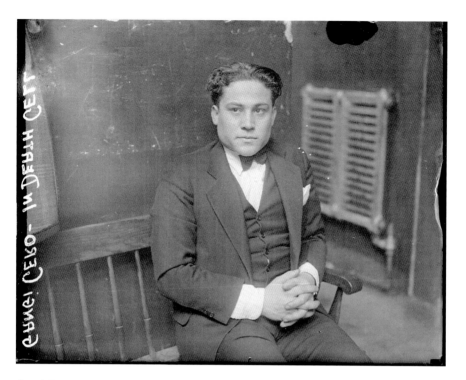

Gangi Cero. *Courtesy of the Trustees of the Boston Public Library/Print Department.*

awful chair." Furthermore, he admitted that he'd been in trouble with the law before because of a bootlegging rap but continued to insist that he had nothing to do with the murder of Joe Fantasia.

Later, Cavagnaro spoke to Detective Madden about the interrogation and told him that Cero was a very emotional boy and he thought that he would probably stick to his story. But Cavagnaro also tipped Madden on something else he might want to look into. According to author John Makris, Cavagnaro, being from the North End and knowing all the major players in the neighborhood, said to Madden, "I understand Fantasia was quite a ladies' man. You might find a motive for the killing there, Mark. I know Cero worked for Sam Gallo. I say all this because I can't imagine any other connection Cero would have with Fantasia that would result in murder. A motive of jealousy would fit in nicely."

Cavagnaro was probably privy to the gossip on the street. The word was that it was all about a woman—and her name was Philomena Romano. According to writer Max Haines, Philomena "was a tall, dark, beautiful woman who had broken many hearts as a love 'em and leave 'em siren."

Station One, North End. *Original photograph by Catherine Reusch Daley.*

HISTORIC CRIMES IN THE HUB

Saratoga Street in East Boston. *Courtesy of the Trustees of the Boston Public Library/Print Department.*

The wagging tongues of the North End probably were talking about how Philomena had been Sam Gallo's live-in lover for five tempestuous months before she left him—to become the mistress of her brother-in-law, who was none other than Joe Fantasia.

Other than Cavagnaro's speculation on Cero's connection to the murder, Madden could find no other link after questioning dozens of people. In addition to talking to most of the people who were on the street on the day of the murder, Madden tracked down all of Fantasia's closest friends, and none of them had ever even heard of the name Gangi Cero before the murder.

Then it was time for the detectives to make their way to 334 Saratoga Street in East Boston, the victim's former residence and the home of his wife, Josephine—and his sister-in-law, Philomena Romano.

The detectives were met at the door and then quickly ushered into the parlor. There before them were the weeping Josephine and the stoic Philomena. Josephine, when questioned about the murder, answered that she knew nothing of the murder or Gangi Cero between the bursts of sobbing and muttering, "My Joe is dead…my Joe is dead." Philomena, cool

as a cucumber, announced, "I don't know anything about it. I was home all day Saturday."

Next, Madden and Mooney focused their attention on Samuel Gallo—Cero's boss. According to writer Max Haines, they did a little background check on Gallo and found "Gallo made a living in stolen clothing and that Cero was his assistant and enforcer." Armed with this information, the detectives decided to pay a visit to Sam Gallo. When they met Gallo, the first thing they noticed was the fresh scar, four inches long, across his face.

Looking Gallo up and down, Madden said, "Where did you get that scar, Sam?"

Cautiously choosing his words, Gallo quietly replied, "Flying glass did it—one of those things."

In a tone of disbelief, Madden just uttered back, "Yeah."

Madden proceeded to ask Gallo about his relationship with Cero and about the crime. Gallo told Madden that, as far as he knew, Cero had no connection to Fantasia—citing the fact that Cero had very few friends. He also told the detectives that he liked Cero and kept a sharp eye on the youth in order to keep him out of trouble. His opinion was that Cero was innocent, and he rejected the idea that Cero had been hired to kill Fantasia.

Probably at about this time, that gut feeling—that cop intuition—began to tell Madden something just wasn't right. He might have begun to think that maybe Philomena was with Fantasia when he was murdered due to her strange announcement that she was home all day. Another thing might have struck a chord with him—the nervous way Pasty Vallerelli, the barber, answered him when he asked if someone was with Fantasia. Whatever was going through Detective Madden's mind, we can only speculate. But we do know that he decided to go and re-interview "Paddy-wagon" the barber.

Madden and Mooney arrived at 94 Prince Street and entered the barbershop, finding Vallerelli alone.

Madden led by using an old police trick—make the subject think you know more than you really know. In an authoritative tone, he said, "All right...I know something you know, but I want you to tell me."

"That's so?" the barber responded with a quizzical look on his face. "I tell you I don't know anything."

In a frustrated and angry voice, Madden shot back, "Am I going to tell you?"

"Jeez! Tell me what?"

"You know what I'm going to tell you."

"I swear I don't."

"Stop your lying. There was someone in the shop with Fantasia that Saturday afternoon, wasn't there?" Madden shouted at the bewildered barber. Then, to drive the point home, Madden said, "You know where you're going to wind up if you don't tell me the truth, don't you?"

"Okay, okay," Patsy whimpered submissively.

His eyes darting about and wringing his hands, Patsy broke and said, "She had nothing to do with it. You don't want to make trouble for her, Mr. Madden; she's a good kid. I promised her I wouldn't say anything."

Still he hadn't gotten a name from Patsy, so he continued the ruse and said, "What else did you promise the beautiful Philomena?"

"Nothing," Patsy mumbled.

"They left together and walked down the street together, didn't they?" Madden asked.

"I guess so," was the answer.

Madden and Mooney now knew that they had an eyewitness to the murder who could tell them who shot Joe Fantasia. They hurriedly crossed over the Mystic River into East Boston and arrived at 334 Saratoga only to find the widow Josephine but no Philomena. Josephine told the officer that Philomena had packed all her belongings and left without a word the day before. Furthermore, Josephine said that she had no idea why she left or where she might have gone.

Before leaving, the poor widow was apprised of the situation and all the sordid details by the two officers. Her reaction was that of every wife who suddenly realizes that the man she thought she knew wasn't that man at all. She began to violently sob. Half cognizant and half in denial of what she had just heard, Josephine cried out that Philomena could never have done such a thing as take her husband. And certainly she could in no way be mixed up "with that Cero man in the killing of my man."

In an effort to locate Philomena, notifications were sent out to every police department on the East Coast bearing Philomena's picture and description. Days went by, and there was no sign of Philomena—she had vanished.

In the meantime, Gangi Cero was indicted for murder and would stand trial in November 1927. Somehow, Cero had been able to procure the services of one of Boston's leading attorneys: William R. Scharton. The buzz in the courtroom must have been how could a poor laborer such as Cero pay the fee for Scharton? Who was Cero's benefactor?

The trial lasted several days. Witnesses who saw Cero fleeing the scene took the stand against him. Although none of them saw Cero actually shoot Fantasia, just the fact that he was identified as fleeing the scene was enough

for the jury. On November 17, at 10:05 p.m., after four hours and thirty-five minutes, the jury came back with a verdict of guilty of murder in the first degree, which almost certainly would carry a sentence of death in the electric chair. The sentencing was not immediate because, as was custom, the defendant would be given the opportunity to file appeals.

Two motions for a new trial were rejected by the court, and the day of sentencing was set for July 6, 1928. On that day, heavy security was implemented at the court building—police officers were stationed outside the courtroom, and all entryways were blocked save one, the main entrance, where all persons entering were searched.

Gangi Cero was brought up from the Charles Street Jail looking gaunt and pale from months of incarceration. Just as the sentence was to be passed, the defense was able to perform some skillful legal maneuvering in which the judge had no option but to order a continuance until September 19. Court was adjourned, and Cero was remanded back to the Charles Street Jail while his lawyers tried to formulate a plan to save his life.

Then, on September 17, Lewis Smith, the star witness for the prosecution, reported that he'd been offered $2,500 by Sam Gallo and the brother of the

The Charles Street Jail. *Courtesy of the Trustees of the Boston Public Library/Print Department.*

prisoner, Genaro Cero. It was a bribe to sign a document stating that he'd testified falsely at the trial. The deal hadn't been struck, only the offer made.

A sting was set up with the cooperation of the police. Smith called Gallo and told him he would meet him at a store on Hanover Street and sign the document for the cash. Smith arrived at the store to find both Gallo and Genaro Cero sitting there waiting for him. He went over to the two, and quickly a document was produced for Smith to sign. Smith balked, saying that he needed to think it over for a day or so. The two conspirators were not happy with this and tried to convince him to sign it on the spot. Smith persisted, and the two relented, agreeing to give him a day. As the group was leaving the store, the police swooped in and arrested the three. Later, Gallo would realize that Smith had betrayed him when only he and Cero were brought before the judge during arraignment.

Sam Gallo and Genaro Cero were quickly tried and convicted of obstructing justice through a conspiracy and sentenced to serve two years at the Charles Street Jail. Also about this time, it became apparent that it was Gallo who was paying the legal fees for Gangi Cero. It came out that he had paid between $1,300 and $1,500 to Attorney Scharton for the defense.

As the bribery sting, arrest and trial were unfolding, September 19 arrived, the day of sentencing for Gangi Cero. Once again, he was brought from the bowels of the Charles Street Jail into the light of the courtroom, and sentence was passed: death by electrocution. The date was set for November 4, 1928. Cero was ordered to be held over at Charles Street Jail until ten days before the execution, when he would be transferred to Charlestown State Prison for the sentence to be carried out in the death house.

According to author John Makris, after hearing the news of the sentencing, "Madden's mind wasn't exactly serene. He couldn't help wondering if the outcome had been different if Philomena Romano had been located, and persuaded to tell what she knew of the murder."

Something just wasn't right. When all things were considered—Gallo's funding of the defense, his attempted bribery and Philomena's disappearance—Madden decided that he would redouble his efforts to find Philomena. We can only imagine the thoughts that must have run through his mind. Where was she hiding? What or whom was she hiding from, or could it be possible someone was hiding her? Did she actually see the murder being committed, and who was the real murderer?

Then something happened that would really cause Madden to question the verdict for Gangi Cero. Ironically, both Gallo and Cero were being kept at the Charles Street Jail on their separate sentences. On October 12, there

was a Columbus Day football game put on for the prisoners. Normally kept in solitary, Cero was allowed to watch the game under guard of the jail's two biggest officers. After the game was over, he was being escorted back to his cell when he saw Sam Gallo among the crowd. Breaking away from his two hulking chaperons, he launched himself toward Gallo, pulling a stiletto that had been hidden in his clothing. Gallo stood frozen as this freight train of anger roared toward him and eventually knocked him to the ground. Before anyone could pull him off, Cero was able to inflict three deep stab wounds to the chest of Sam Gallo, one nearly striking his heart. The guards were able to separate the blood-covered convicts—Cero was brought back to solitary, and Gallo was brought to the prison doctor. The doctor realized there was nothing he could do for Gallo, and he ordered him rushed to Massachusetts General Hospital, which was just down the street. An emergency surgery was performed, and Gallo narrowly escaped death.

Detective Madden was probably asking the same questions everyone else was asking. Why would Cero try and kill the man who had been trying to help him—the man who paid for Cero's defense, the man who was in jail himself for trying to tamper with a trial witness to get Cero's verdict thrown out? What was the motive?

The motive became very apparent just two days before Cero was to be executed. On November 2, Cero made a request for the assistant district attorney, William McDonnell, and the chairman of the parole board, Frank Brooks, to make a visit to his cell in the death house at Charlestown State Prison. The men, escorted to the cell by Cero's lawyer, entered his cell to find a withered man with a prison pallor. Cero welcomed them cordially, and all sat down. Again, he vigorously denied that he was the killer but now had something new to say—Sam Gallo was the real killer!

He then told the officials the whole story. At about 3:30 p.m. on June 11, 1927, he and his boss, Sam Gallo, drove to Snow Hill Street, parked and then walked down to Prince Street. Gallo told Cero there was a man he wanted to see. As they were walking down Prince Street, before he knew it, Gallo pulled a revolver from his waistband and walked up to this man and shot him several times in the back and then just melted into the crowd on the busy street. Cero told the officials that he later found out the man was Joe Fantasia.

Cero next told of how he was frightened and began to run up to Hanover Street and then into the pastry shop where he was arrested. He went on and further stated that he'd been visited in prison by an attorney hired by Gallo, who told him to take it easy. Next, Gallo came to see him and promised him

that he would gain his freedom if he wouldn't speak of Gallo's connection to the murder.

He had kept his mouth shut and, slowly but surely, realized that Gallo was not going to come forward and that he was going to die for a crime he did not commit, so he decided to tell his story. As he was finishing his story, Cero, in his thick Italian accent, cried, "My father died of a broken heart, and I soon shall be dead! Mr. McDonnell, you can't do nothing for me. But you told the jury I was a bad boy. And when I am dead, I want you to tell the jury I was a good boy. That is all."

When asked about Cero's story, Gallo, from his hospital bed, vehemently denied the accusation and would say nothing further.

The defense attorneys swung into action, appearing before the judge who had heard the case, Judge Cox, then the governor of Massachusetts Alvan T. Fuller and finally Justice Holmes of the U.S. Supreme Court in order to try and get another stay, to investigate the accusations Cero made. While the mechanism of justice slowly proceeded, Governor Fuller decided to give Cero a temporary reprieve until word came from the courts on his case.

By the week's end, the Supreme Court had decided not to hear the case, and the date of execution was re-set to November 9.

More information began to reach the ears of the police. An informant who wished not to be identified came forward to relate what he knew. He explained that Sam Gallo and Philomena Romano had been romantically involved with each other up until the spring of 1927. Apparently, Philomena left Gallo for Fantasia, and three weeks before the murder, Gallo happened to meet Fantasia and Philomena on Richmond Street in the North End. The witness told how Gallo got into an argument with the two and tried to get her to go back with him. When she refused, he called her a whore. Philomena then pulled a knife from her handbag and slashed Gallo across the face. Screaming from the pain and bleeding all over himself, Gallo turned to Fantasia, pointed his finger in his face and yelled, "This is all your doing! You'll be riding a hearse soon!"

The picture was now becoming much clearer. It seemed that the murder had been committed by spurned lover Sam Gallo in retribution for Fantasia stealing his girl and the slashing incident. But there was just one day until Cero would be executed. The information from the unidentified source was not enough to stop it. The only person who could save Cero now was the missing Philomena Romano.

On the evening of November 8, Gangi Cero sat in his cell waiting for the inevitable—which was to come in just hours. Detective Madden sat at his

MURDER & MAYHEM IN BOSTON

The Massachusetts Statehouse. *Courtesy of the Trustees of the Boston Public Library/Print Department.*

desk in Station One most probably thinking that it was Gangi Cero's last day. The workday was over and he was getting his things together to go home when his phone rang. He answered it.

The woman's voice on the other end asked, "Mr. Madden?"

"Yes, speaking. Who is it?"

"This is Philomena Romano. I want to see you. I'll tell you who killed Joe Fantasia!"

When he heard this, Madden must have fallen out of his chair. Just hours before Cero was to die, here she was—the key, the linchpin that could save Cero's life. But was it too late? Madden immediately called the governor to apprise him of the latest information. He told him that he would be in his office within the hour with proof that Cero was innocent.

Madden arranged to meet Philomena at South Station. When he arrived, she was waiting for him on the corner. She quickly got into his car, and they sped over to the statehouse to the awaiting Governor Fuller. Along the way, she told her story to Madden and would repeat it for the governor. She explained, "I was with Joe Fantasia when he walked out of the Prince Street

barber shop. Sam Gallo, walking with another man, pulled a gun out and shot Joe. I didn't want to talk before because I was afraid of getting into trouble. I thought the name Gangi Cero was the name Sam Gallo gave to the police. I never bothered to read the newspapers."

She continued, "Two days ago, I read in the newspaper that Gangi Cero was a real person and not Sam Gallo, and he was going to die in the electric chair. I had to tell the truth, I couldn't have an innocent man's death on my conscience."

"Would you go into court and under oath swear that Gallo is the murderer and that Cero is not the man?" the governor asked.

"Yes," she replied.

The governor continued, "Would you stand up and swear you saw Gallo shoot Fantasia?"

Again the reply was, "Yes."

Then the governor said, "I think she ought to have the chance to tell that in court."

Governor Fuller issued a short stay of execution pending the court's decision on hearing the testimony of Philomena Romano. Just four hours before Cero was to die in the electric chair, Warden William Hendry walked into Cero's cell and gave him the news—he would not have to die tonight.

The next morning, Judge Cox listened as Philomena told her story. She began by telling him that she had waited out on Prince Street while Fantasia got his shave, he came out and they walked toward Salem Street. "Something made me turn, and I saw Sam Gallo with a gun in his hand and he started shooting," Philomena told the judge.

She said she didn't know Cero and said she stayed until the automobile picked Fantasia up and took him to the hospital and then left the scene.

After hearing Philomena Romano, the judge decided that the matter should be brought to the grand jury.

The grand jury met on November 14, and to everyone's surprise, Philomena repudiated her previous statements to the judge and the governor. She was immediately arrested and charged with perjury. Within a day, an affidavit was filed by the defense in the name of Philomena Romano saying that she had told the truth initially to Judge Cox and Governor Fuller but then failed to tell the grand jury the truth because she feared retribution from Gallo and his friends.

While the courts were considering action on the affidavit, a new governor had been elected—Fred G. Allen—and he decided to suspend any further action on carrying out the execution until the court made a determination.

MURDER & MAYHEM IN BOSTON

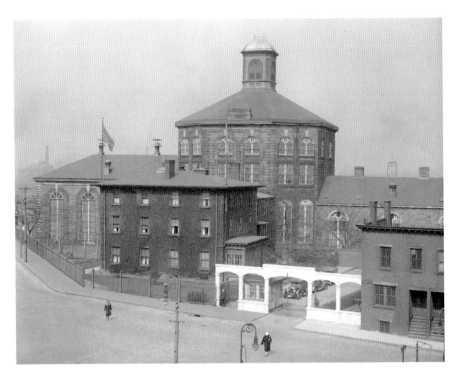

Charlestown State Prison. *Courtesy of the Trustees of the Boston Public Library/Print Department.*

It was decided that the grand jury would hear the testimony once again, and on January 8, it was reconvened. This time, Philomena told the truth and explained her prior recantation due to fear of reprisals from Gallo. The grand jury handed down an indictment against Samuel Gallo for murder in the first degree. The trial date was set for February 18, 1930.

The trial lasted ten days. The prosecution brought up both Cero and Philomena Romano to tell their stories, and Gallo took the stand in his defense to deny everything they had said. The jury deliberated for seven hours and came back with a verdict of guilty of first-degree murder.

Now, due to the conviction of Sam Gallo, a situation arose that had never before happened in the history of jurisprudence—two men stood convicted separately for a murder that only one of them could have committed! This was territory that had never been trodden before. How would the courts deal with this situation?

The case was then brought before the Supreme Judicial Court of Massachusetts for a ruling. After a week, the court came back with its opinion: both verdicts would be set aside, and both men would be retried

for the case and retried together. The date for the new trial was set for September 22, 1930.

The prosecution and the two defense teams began to prepare their cases. It was critical for Gallo's conviction and Cero's acquittal to have the testimony of Philomena Romano. When Cero's defense team went to contact her to prep her for trial, she was nowhere to be found—she'd disappeared once again!

Where was Philomena? The question was on everyone's lips again. Even the newspapers got into the act, writing stories about the beautiful missing eyewitness. But she'd vanished as quickly as she had appeared to save Cero.

Inspector Cavagnaro got a line on Philomena. Through channels, he heard she was holed up in Brooklyn, where she had relatives. The inspector decided to drive down and try to find her but along the way was involved in a car wreck and was killed. There was speculation in the press that he may have been driven off the road, but this was pure speculation; the truth was it was just an accident.

The district attorney then turned to the Pinkerton Detective Agency—the original "private eye." They put on a massive search for Philomena. They checked out reports of her in a Mexican resort, in Canada and in Italy. They also checked out a report that she was a prisoner of a "Black Hand" boss in Providence. None of the leads turned up a thing, and it was as if Philomena was just an apparition that had evaporated before everyone's eyes—she was gone.

Before the trial began, it had to be settled—would the transcript of Philomena's previous trial testimony be accepted as evidence since she could not be found? The ruling was that it would indeed be considered evidence and could be used at trial.

On the first day of the trial, there was a motion to have separate trials. The judge denied the motion, and the trial of Gangi Cero and Sam Gallo proceeded. One of them would be convicted, and one would be a free man.

The previous trial's testimony of Philomena was read into the record, and both Cero and Gallo took the stand in their own defense. Cero told how he had had no knowledge of what Gallo was going to do that day, and Gallo repudiated the testimony of his accusers.

On the final day of the trial, both defendants were allowed to make statements before the jury went out to deliberate. Cero faced the jury and in broken English said, "Gentlemen, I am innocent. I am not the man who shoot. I am no the man to die. I am innocent." Then Gallo rose and walked over to face the jury and said, "I was not in the North End on June 11,

1927. I know nothing about the shooting. I leave my fate in the hands of the honorable judge and the honorable jury."

The jury came back, and the verdict was that Samuel Gallo was guilty of murder in the first degree and Gangi Cero was acquitted. Finally—not guilty! Elated, Cero left the courtroom and walked out onto the streets to breathe the air of freedom once again. There was a grand party for him back in the North End, and shortly afterward, he returned to his native Italy.

The saga of "who killed Joe Fantasia?" was not over yet. Gallo's lawyers appealed the case to the Supreme Judicial Court of Massachusetts and won a new trial based on two bits of evidence—the police failed in any way to link the murder weapon to Sam Gallo and there were no prints on the gun that belonged to him.

Another trial was scheduled. Cero came back from Italy to testify, Philomena was still in the wind and very much the same testimony was heard as at the Gallo-Cero trial—but this time the verdict was different. Sam Gallo was found not guilty! He was released and several months later deported to Italy.

Who killed Joe Fantasia? The courts certainly didn't resolve that question legally. Only three people really knew. Two ended up back in Italy, and one faded from the pages of history, never to be heard of again. What really was the truth? After all these years, we may never know for sure what actually happened on that spring day in 1927 when death came to Prince Street.

8
DISMEMBERED

THE GRAYCE ASQUITH CASE

It was lunch break, noontime on October 5, 1936. After a hard morning's work at their WPA jobs at the airport in East Boston, Louis Romani, Anthony Barbare and William Tortorici sat down to have their lunch. Looking up from his sandwich, Louis Romani noticed what appeared to be a burlap bag floating in the nearby shallow waters of Boston Harbor. He decided to investigate, put his lunch down and proceeded toward the bundle followed by the others. When he got near, he leaned over and grabbed the cord with which the package was wrapped. As he began to lift the sodden sack out of the water, the whole bundle opened up, revealing the gruesome contents. To Romani's utter shock, the severed right leg of a woman tumbled out into the shallow water. The three men recoiled in horror, aghast at what was in front of them. Once they regained themselves, they called their supervisor, who in turn alerted the authorities.

As a crowd began to form around the gory remains, the police arrived and took possession of the leg and bag and transported them to Station Number One. From there they were transported to the medical examiner's office. Medical examiner William J. Brickley inspected the contents of the burlap bag. He found that the leg had been wrapped in a newspaper, the date of which was July 12, 1936—almost three months old. As he stripped away the newspaper, he began to examine the leg. It was the right leg of a woman, severed just below the top of the thigh. The leg had been bent at the knee with the ankle bound to the upper thigh with a drapery cord and part of a shoelace. Brickley then began to examine the bag. It was a burlap

East Boston Airport (Logan Airport), early 1930s. *Courtesy of the Trustees of the Boston Public Library/Print Department.*

bag and was stamped, "Selected Maine Potatoes Aroostook Grown Potatoes Liberty Natural Brand 200 Pounds." He also looked at the cord that bound the bundle together and noted that it looked like the same type of drapery cord (sisal cord) that was used to bind the leg. Brickley was later quoted in the newspapers as having said, "It looks like murder to me…the amputation of that leg was much too crude to have been done by a surgeon; I am more inclined to think that this was the work of some person more accustomed to cutting meat."

A profile of the victim emerged. She was probably small with dark hair. Some hair was found on the leg, the color of which indicated that the woman was a brunette. Her shoe size was found to be a size three, which revealed that she was a somewhat petite woman, and the condition of her feet and legs led the medical examiner to deduce that she had been a dancer or was used to walking quite a bit. He surmised that the victim had been between the ages of twenty-five and forty. He also believed that the leg hadn't been in the water more than three weeks.

HISTORIC CRIMES IN THE HUB

Later that same afternoon, Patrick Kane, an East Boston boilermaker, saw a burlap bag drifting in the waters about a half mile below the airport. He waded into the water and brought the bag ashore. He opened it and found two objects crudely wrapped in what appeared to be a green curtain and newspaper. Kane stripped the coverings away and was startled to find a woman's severed naked left leg and a woman's bloody lower torso. Authorities were notified, and the contents were swiftly delivered to the medical examiner's office.

The newspapers reported that as soon as the second bag arrived at the medical examiner's office, Dr. Brickley took it and spread its contents on the table, examining every little bit. He noticed the dates on the newspaper were the same as the bag found earlier and that the burlap bag was stamped with the same "Maine Potatoes" stamp as the previous bag. Dr. Brickley looked more closely at the leg and foot. Then he exclaimed to his assistants as he noticed a little callus on the heel of the small size-three foot, "There's a tiny callused spot on the left foot which may be of value in identification!" He put the leg down and looked up and said, "I've ordered a plastic [plaster] model made of the leg and foot that I am holding down at the morgue. It may come in handy…in the case of a fitting slipper proving the identity of this dead Cinderella!"

More police search crews were sent out to Boston Harbor to drag the bottom and search for more bundles. The victim's upper torso and a head were still missing, and if found, the victim might be more readily identified.

The newspapers' headlines shouted, "Girl's Leg Found at Airport," "Find Parts of Woman's Body" and "Legs and Internal Organs Discovered in Harbor as Police Press Night Hunt." The next day, the police were flooded with calls from people reporting missing loved ones. Astoundingly, at that time, there were over two hundred missing women just in New England.

For several days, police checked into each of the reported missing women. All of them were easily eliminated because none wore a size-three shoe, and the mystery continued. The mystery was front-page news every night. Everything found in the harbor, including a pair of pants, a handkerchief, a smock and a jacket, was all seen as potential clues to the identity, but speculation was all that the papers could offer—until Mrs. Isabelle Murphy walked into the office of Boston police superintendent Edward Fallon. Mrs. Murphy, who was from Allston, told Fallon that her friend Mrs. Grayce Asquith of Weymouth had been missing since September, and she feared that her friend was the murdered woman. She related that Asquith, who had been widowed several years before, had just dropped from sight in September.

Murphy had attempted to call her several times and was unable to get an answer. She also told Fallon that about a week before her disappearance a man they both knew had threatened her friend's life. Afterward, Asquith went to her attorney about this threat. She told Fallon the name of the man but did not know what precipitated the threat, only that the attorney had urged her to take action, which Asquith refused to do.

Murphy then told the superintendent, "There was something strange about it which I didn't understand."

Fallon then inquired if Asquith had many male friends to which Murphy replied, "She was very popular, but I don't think she's seen many of them lately. She's engaged to be married to a war veteran by the name of John Lyons who lives on St. Boltolph Street in Boston."

Then Murphy added that she hadn't been able to get a hold of Lyons either. Fallon posited that maybe they had eloped, but Murphy quickly discounted that, saying, "She wouldn't have done a thing like that without consulting me." As she was leaving his office, Fallon assured Murphy that he would investigate immediately.

Murphy didn't seem to have much faith in the Boston Police Department because almost immediately upon leaving Fallon's office, she went to a phone booth and called Allen C. Wingate, the Weymouth real estate agent who had sold Grayce Asquith her bungalow on Alpine Road near Whitman's Pond in Weymouth. She told him about her friend's disappearance and of her suspicions and then asked him if he could take a ride over to the bungalow to see what he could find out.

Wingate hung up his phone and was soon in his car and on the way to 19 Alpine Road. He walked the few steps up to the front door, knocked and knocked and knocked, with no answer. He then proceeded to investigate the rest of the property and noticed a few odd things. First, he noticed that the garage doors were wide open. Second, he noticed that the big ceramic flower urns that had been located at the end of the driveway were now missing. Seeing some of the neighborhood kids playing in the neighborhood, he walked over and asked them if they had seen Asquith; nobody had. Feeling something was wrong, Wingate drove home, called the Weymouth police and reported, "Folks are wondering about Mrs. Asquith down on Alpine Road. She hasn't been seen around her bungalow for more than a week and doesn't answer her phone. One of her Boston friends, Mrs. Murphy, just called me up. She's afraid Mrs. Asquith is away or maybe ill."

Weymouth police lieutenant John A. Hutchins, the officer who took the call, quickly dispatched a patrol car to the bungalow to investigate.

HISTORIC CRIMES IN THE HUB

Soon, the patrol officers reported back to Hutchins. They had found the front door locked, the garage wide open and the back door open. They did not go in but looked in the windows and told Hutchins that the place was deserted. The Weymouth police began to think there might be a connection between the body parts found in Boston Harbor and the missing Asquith, so they contacted the Boston police about the matter.

Weymouth police chief Edward Butler was notified and decided to investigate on his own. With several officers in tow, he traveled down to the Asquith bungalow. The chief and his men arrived, went around the back of the cottage and entered through the open back door. The back door opened right into the kitchen area. The chief was struck by what he found. On the stove he found kettles and lifted the lids to find half-cooked, moldy food inside. At this, he turned and exclaimed to his men, "Something queer has been going on in here all right. People don't go off and leave a half-cooked dinner unless something is very wrong!" They moved into the little area off the kitchen and found three empty wine glasses with just the dregs left. A closed door blocked their entrance to the rest of the cottage. Chief Butler opened it and walked gingerly into the living room. Upon first glance, everything appeared to be in order, and they moved into the next room, which was Asquith's bedroom. The chief opened the closet, and there on the floor was a tiny slipper, size three. Butler took the slipper and handed it to his officer and ordered, "Rush this slipper to medical examiner Brickley's at once! See if it fits the plastic model of the dead woman's foot and let me know immediately!" The officer hurried out with the slipper in hand.

As Butler was looking through Asquith's bedroom, one of his officers stepped into her bathroom and then let out a scream for the chief to come and look. The chief came to the side of his officer, who was staring blankly at the sight of the bathroom, which was splattered with blood on the floor and in the tub. Right away, they recognized what looked like the footprint of a man in blood on the floor and a partial handprint in the gore on the side of the tub.

As police searched the Asquith bungalow, miles away at the medical examiner's office, Dr. Brinkley was examining the slipper brought in by the Weymouth police. He eased the slipper onto the plaster cast of the foot found in Boston Harbor and excitedly exclaimed, "It's a perfect fit. If this slipper belongs to the missing Mrs. Asquith there is no question but that we have discovered the identity of this dismembered victim!" He went further to state, "Not only is it a perfect fit, but look at this heel!" He took off the slipper and pointed to the slight

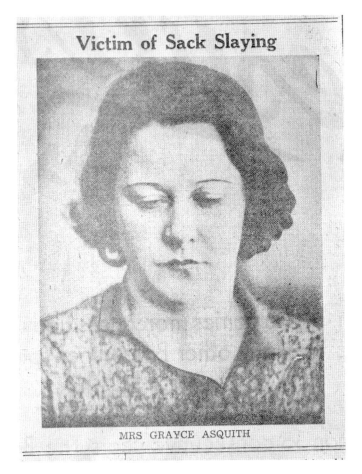

Grayce Asquith. *Courtesy of the Trustees of the Boston Public Library/Print Department, Leslie Jones Collection.*

indentation in the sole and said, "That proves it; it completely fits the callus on the heel of the dead woman!"

Police continued their search of the widow's cottage. They also began to dig into Asquith's checkered background. It seems the Weymouth police knew her well and referred to her as the "Merry Widow." She was known to police for several reasons. On a few occasions, police had been called to her house to break up loud parties. It seems that Asquith would have parties night after night in the summertime. It was known that her friends would come to her little bungalow in cabs from Boston and that many of them were men. Police also knew her because, approximately a year before the murder, she was arrested on a drug charge.

HISTORIC CRIMES IN THE HUB

John Lyons. *Courtesy of the Trustees of the Boston Public Library/Print Department, Leslie Jones Collection.*

When neighbors were interviewed, they related how Asquith "liked the gay life" and that she would have frequent parties at her bungalow. Her best friend, Mrs. Murphy, and her husband were frequent visitors to the bungalow they said. Furthermore, she was most commonly seen in the company of two men: her fiancé, John Lyons, a disabled World War I veteran from Boston, and Oscar Bartolini, who was from Quincy and was said to be her handyman and sometime chauffeur. Bartolini was a rather imposing Italian with a mustache and a jagged scar across his face. Neighbors also told police that they hadn't seen the widow since September 20, when she was seen in the company of Lyons and Bartolini at her bungalow.

MURDER & MAYHEM IN BOSTON

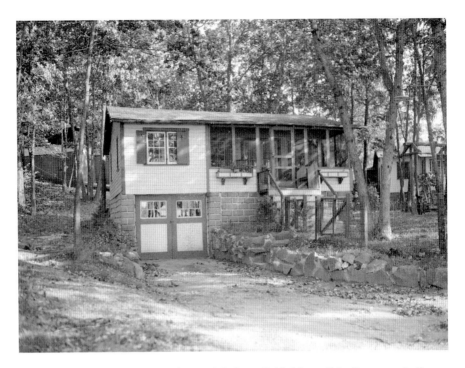

Asquith bungalow. *Courtesy of the Trustees of the Boston Public Library/Print Department, Leslie Jones Collection.*

Police continued their search of the bungalow into the evening, finding more evidence of mayhem. They found spatters of blood near the fireplace in the living room, bloodstains on the sheets in the bedroom and bloody towels rolled up and hidden in the linen closet.

Chief Butler put a call in to Superintendent Fallon of the Boston police informing him of the developments and the likelihood that Mrs. Grayce Asquith was the victim they were looking for. Superintendent Fallon along with Boston police commissioner Eugene Sweeney and deputy superintendent James Claflin came to the bungalow. With them was the woman who had first reported Asquith missing, Mrs. Isabelle Murphy. Murphy was asked to identify Asquith's slipper to confirm that it was in fact hers, which she did. Then she was asked to step outside while Butler debriefed the Boston cohort. As Butler laid out what he had found in the bungalow and what he had learned from the neighbors, the name Bartolini came up. At this, Superintendent Fallon exclaimed, "That's the name of the man Mrs. Murphy claims threatened Mrs. Asquith's life." Fallon answered by saying, "I sent word to Quincy to the Quincy police to pick up Oscar

HISTORIC CRIMES IN THE HUB

Bartolini. They found him late this afternoon, and they are holding him down at police headquarters until we can come down. However, I can't say as much for Lyons; I can't get a line on him." Fallon responded, "Nobody seems to," and told Butler that he had sent a detective to Lyons's apartment on St. Boltolph Street and was told by the landlady that he hadn't been seen since the nineteenth of September, when he was picked up by a man named Bart. The detective gained entry to the apartment and found all of Lyons's clothes and possessions undisturbed and an unopened fifty-dollar veteran's disability check in his mailbox. The police quickly surmised that this "Bart" was Oscar Bartolini and hastened to Quincy to interview him.

At the Quincy police headquarters sat the scar-faced, hulking Italian Oscar Bartolini. The contingent from the Asquith bungalow arrived at about midnight and began to question him. Still not fluent in English, he required an interpreter at times to speak. Bartolini was asked if he had ever threatened Mrs. Asquith. Bartolini adamantly denied that he had, saying, "I never do such a thing! I like her. She was my friend, why should I want to hurt her?" The police interrogated Bartolini all night, and his story emerged. He recalled that on September 19, Asquith had asked him to drive out to Boston to pick up her boyfriend, Lyons, and bring him back to the bungalow. Bartolini said that he had done this many times as he had acted as a sort of chauffeur for Asquith and her boyfriend in addition to being her handyman. He continued by saying he brought Lyons to the Asquith bungalow and that Mrs. Asquith invited him to have a glass of wine with her and Lyons, which he did. Bartolini then stated that after they shared a glass of wine together, he left, and that was the last he'd seen of both of them. When asked about the half-cooked meal on the stove, he explained that Asquith had ordered the food from the Weymouth Beef Company a few hours before and that it had been brought to the bungalow by a delivery boy. His story squared with the empty wine glasses and the half-cooked meal. Police pressed him further but couldn't get anything more from him, so they decided to hold him as a material witness.

A search warrant was obtained for Bartolini's Washington Street apartment, which was above a curtain shop. What police found in his rooms would prove to be very damning. Stuffed behind Bartonli's bed was a partial set of green curtains matching the ones used to wrap the legs and lower torso. Investigators found a large butcher's knife with what appeared to be human blood on it rolled up within the curtains. Downstairs in the curtain shop, police also found other sets of matching green curtains. Lying in plain sight on the floor were potato bags similar to the ones the body parts were

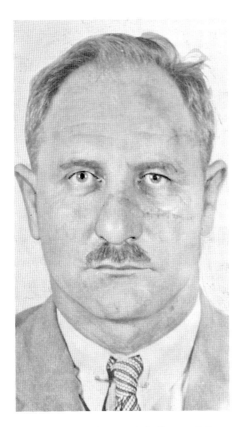

Oscar Bartolini. *Courtesy of the Trustees of the Boston Public Library/Print Department, Leslie Jones Collection.*

found in, and in the storage area of the apartment, bloody car seat covers were found.

Knowing that Asquith had gone to her attorney about the threats Bartolini was making, the police interviewed her lawyer, George Locus, about the incident. It was then the police learned of another crime Bartolini had committed against Asquith. Locus told police that Asquith had confided in him and told him that on the night of August 17, while Lyons was away, Bartolini had gained entry to Asquith's bungalow, woke her while she was sleeping and then violently raped her. Afterward, he threatened to kill her if she told anyone. Locus urged her to go to the authorities, but she decided not to act due to the embarrassment it would bring and the threats from Bartolini. Locus also told police that Asquith feared Bartolini to the point of fleeing her bungalow to the safety of her friend Mrs. Murphy's home.

When questioned about his whereabouts in the days after the murder, Bartolini mentioned that he had become ill on Monday, September 19, and went to his doctor, Samuel Lerner, in Quincy. Detectives went to Dr. Lerner's office to check on Bartolini's story, which the doctor confirmed. However, the doctor also added a surprising detail to his confirmation. He told investigators that Bartolini had the unmistakable smell of death about him—a smell the doctor was very familiar with from his days of handling bodies as a medical student. The doctor added that he asked Bartolini about the stench, and Bartolini had explained it away by telling the doctor he was a part-time chef and got the smell from handling food.

Detectives also began to look into the background of Oscar Bartolini and found out about an interesting incident that had happened a year earlier in

which Bartolini came to blows with a man over the affections of another woman. It made the newspaper, and they termed it a "love duel." On June 29, 1935, Bartolini was involved in a fight in which his nose was nearly severed by the knife of one Luigi Messini. The wound left a deep scar across Bartolini's face. It appears that he and Bartolini were fighting over Mrs. Jeannne LaLiberte, Messini's "paramour." Messini claimed he was attacked by Bartolini and that he had defended himself with the knife. Eventually, the incident was ruled as self-defense, and no charges were brought against Messini. Detectives must have seen this as more evidence of a pattern of violent behavior on Bartolini's part.

While the detectives were digging into Bartolini's past, other detectives were digging into Asquith's yard and tearing apart the bungalow for further evidence. The head and upper torso of Asquith still had not been found, nor had the remains of her lover, John Lyons. The police began a thorough search of the house for any evidence or the remains of the two. As hundreds of onlookers watched, the front and the backyard were dug up and Whitman's Pond was dragged, but searchers found nothing.

Inside the bungalow, police had better luck. Upon closer investigation, there were small bloodstains in the living room near the fireplace and in the bedroom. Police deduced that Mrs. Asquith had been attacked in the living room and then brought into the bedroom. When the police began to dismantle the bathroom, they found, to their horror, chunks of flesh clogging the drain in the bathroom and in the pipes of the cesspool. The floor with the bloody footprint and the tub with the bloody handprint were removed as evidence.

Police widened their search to likely places that a body would be dumped. Boston Harbor was dragged, and two bodies were found. Neither of the bodies was connected to the case. Police were never able to identify either of the bodies.

The Quincy Granite Quarries, a favorite place of criminals to dump bodies, was searched and another body was found, but it turned out to be another unidentifiable John Doe.

The police boat *Watchman* was patrolling Boston Harbor on the morning of October 23, 1936, when it almost hit a floating barrel. When the boat veered away to avoid the barrel, one of the crew members noticed something floating just beneath the barrel. A grappling hook was thrown out, and the object was pulled in. It was a small package wrapped in what appeared to be bloody green curtain cloth. The package was opened, and it was found to contain the bloated decayed head of Mrs. Grayce Asquith.

Removal of the bathtub for evidence. *Courtesy of the Trustees of the Boston Public Library/Print Department, Leslie Jones Collection.*

A large crowd gathered around the bathtub. *Courtesy of the Trustees of the Boston Public Library/Print Department, Leslie Jones Collection.*

HISTORIC CRIMES IN THE HUB

Norfolk Superior Court. *Original photograph by Catherine Reusch Daley.*

The head was brought to the medical examiner Brickley. He determined that the curtain that the head was wrapped in was identical to the curtains that the other body parts had been wrapped in. He also made the determination that "the woman had been struck several times over the head with a blunt instrument, making small fractures beside the major fracture extending from the right temple to the top of the head." He further stated in his report that "this head was severed from the body by a person with superhuman strength with a heavy keen-edged knife, probably the same one which was used to dismember the corpse."

On October 30, 1936, Oscar Bartolini was indicted by a grand jury for the murder of Grayce Asquith. No indictment came down on the murder of John Lyons due to the lack of a body. However, officials involved believed he had probably been killed as well.

The trial began on September 7, 1937, at the superior court at Dedham. Sitting on the bench was Judge George Francis Leary. The prosecution was led by District Attorney Edmund R. Dewing. For the defense, Bartolini had George B. Lourie representing him.

The prosecution presented its case first. Although the handprint from the tub was never connected to Bartolini, the footprint on Asquith's bathroom floor was—the highlight of the case included bringing a footprint expert in from Vermont, who testified that, in his opinion, the bloody footprint found

MURDER & MAYHEM IN BOSTON

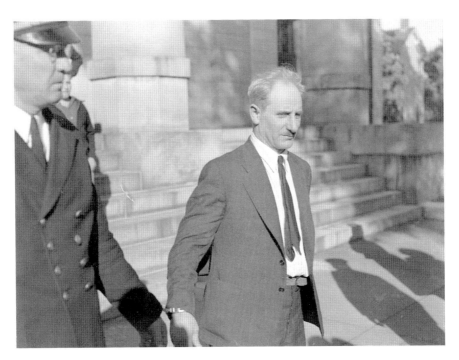

Bartolini at court. *Courtesy of the Trustees of the Boston Public Library/Print Department, Leslie Jones Collection.*

Former site of Norfolk County Jail; now a condominium complex. *Original photograph by Catherine Reusch Daley.*

HISTORIC CRIMES IN THE HUB

on the bathroom floor was that of Bartolini. When the prosecution rested, it was a pretty sure thing that Bartolini would be convicted due to a mountain of physical evidence as well as the various witnesses against him.

In essence, Bartolini's defense was that he was not the murderer but that the missing boyfriend, John Lyons, was. The argument didn't hold up very well when compared to the evidence against him, and the jury voted a guilty verdict.

After the guilty verdict, Bartolini was informed that he would be given his sentence the next day. That night, he was remanded to the Norfolk County Jail at Dedham, just around the corner from the courthouse. As he was coming back from dinner, Bartolini climbed up on the top rail of the third tier of the jail, which was about fifty feet high, and took a swan dive. It was said that as he fell, he cried out, "Here I come, Grayce." The fall should have killed, him but it didn't. Bartolini survived with only a broken arm. The next day, he was sentenced to death in the electric chair and was sent off to Charlestown State Prison.

In 1939, owing to the fact that John Lyons had never been found, Governor Charles Hurley, just seven hours before Bartolini was due to be executed, commuted his sentence to life in prison.

In 1961, at the end of his term as governor, Francis Furculo pardoned Oscar Bartolini. Furculo explained that he had always felt that it was unfair to sentence Bartolini to life in prison when John Lyons had never been found, which in Furcolo's mind left doubt as to Bartolini's guilt. However, it is important to note that Lyons's sisters were interviewed years later, and they stated that they had never seen or heard from their brother since the time of the Asquith murder.

As soon as Bartolini stepped onto free soil, he was arrested by an official of the immigration department and deported back to his native Italy, where he spent the rest of his life in the city of Florence…as a free man.

9
THE GIGGLER

THE KENNETH HARRISON CASE

In the mid- to late 1960s, with the Boston stranglings still fresh in the psyche of Boston, a series of incidents occurred. One was very noteworthy, and the others were barely mentioned in the press. In the end, they would all be found to be the work of a psychopathic serial killer who would call himself "the Giggler."

On the evening of January 28, 1966—one of those frigid midwinter New England evenings with the temperature hovering in the low teens—it was business as usual at the Paramount Hotel. The Paramount, located at 17 Boylston Street, was an eleven-story fleabag with a barroom on the ground floor. It was in the area then known as "the Combat Zone." The zone was Boston's red-light district, and the Paramount Hotel was not far from venues such as Teddy Bare Lounge, the Two O'clock Club, Club 66 and the Naked I, as well as numerous adult bookstores and other cafés and bars. The residents of the hotel were usually transients, and the bar on the ground floor was normally inhabited by navy men from the ships that docked in the nearby harbor and out-of-towners.

At about 6:30 p.m., as the night was just getting started, a massive explosion erupted from the bowels of the hotel. The explosion was so tremendous that it caused the sidewalk outside the hotel to collapse, the floor in the barroom fell into the cellar and it shattered storefronts and windows for blocks. Patrons of the bar were rocked into the air by the concussion and then flung through the floor into the basement—some of them crushed to death by the falling debris. One of the surviving patrons was Kenneth Harrison, who later told

HISTORIC CRIMES IN THE HUB

Paramount Hotel. *Courtesy of the Trustees of the Boston Public Library/Print Department.*

reporters about how he was sitting at the bar with a girl when the explosion hit. He said, "I reached out for her hand and nothing was there, she had gone through the floor. Then all of the sudden I was in the cellar, too, and I could see her arm sticking out of some wreckage."

Flames shot up twenty to thirty feet high, and it soon became evident that the fire was being fed by a gas leak. The fire rapidly shot through the hotel. Many of the hotel's guests were trapped in the upper floors. The Boston Fire Department was soon on the scene. Many of those guests were rescued by ladder, but due to the icy cold conditions, the work of the firefighters was impeded by their hoses freezing up and the hypothermic conditions on that cold night. It took until the next day to get the flames under control. In the end, the final death toll would come to eleven lost souls.

An investigation was conducted, and fire inspectors found that a known arsonist had been in the area at the time and was suspected of having something to do with the fire. However, the investigation concluded that the explosion was due to a crack in a gas main underneath the hotel.

On May 24, 1967, the body of six-year-old Lucy Palmarin of South Boston was found floating in the Fort Point Channel. The finding of the body was barely noted by the press, and the death was ruled accidental by the coroner.

Fort Point Channel. *Original photograph by Catherine Reusch Daley.*

HISTORIC CRIMES IN THE HUB

On June 15, 1969, at 1:30 a.m., a call came in to the Boston police, and according to former homicide detective Captain Jack Daley (no relation to the author) of the Boston police and author of *Boston's Finest: Callbox to Court House*, the exchange was as follows:

> **Police Operator:** *"Boston Police."*
> **Caller:** *"My Dear, at the corner of Washington and Kneeland Street, in a construction site...There'll be a man down in the water, dead...The Giggler...Ah ha ha ha."*

Police immediately responded, went to the site and found the body of thirty-four-year-old Joseph Breen, with his head bashed in, half submerged in a water-filled hole at a construction site at the corner of Kneeland and Washington.

In the days that followed, the police investigation into the case didn't turn up much, and the press coverage was minimal.

On November 26, 1969, the body of seventy-five-year-old Clover Parker from Boston's South End was found washed ashore near the Gillette Factory at the southern end of the Fort Point Channel. Again, the incident was barely noted in the press, and the death was ruled accidental.

On December 26, 1969, nine-year-old Kenneth Martin left his Dorchester home telling his mother he was headed to downtown Boston to buy some Boy Scout equipment. His mother would never see him again—alive.

According to Daley, who was a sergeant at the time, "The juvenile officers in Dorchester—Frank Olbrys, Edward Kinneally and John Murray—investigated the circumstances of the case." They found that the boy had been seen with a thirty-one-year-old out-of-work cook and drifter named Kenneth Harrison. The case went somewhat cold after a couple of weeks when nothing else turned up on either the boy or the drifter. In his memoir, Daley further tells us that, two weeks after the boy's disappearance, the police received "an anonymous call stating that the boy could be found under South Station." When first built, the lower level of South Station was originally intended for commuter trains, but it was abandoned and never used after it filled up with smoke because the New Haven Railroad had not electrified its commuter operations. Most of it was destroyed after reconstruction in the 1980s. But in 1969, Daley says that it was "a vast area of tunnels, catacombs, storage rooms and in one area a bowling alley where sometimes the boy worked as a pinsetter." Police knew that Kenneth Harrison frequented this bowling alley, so they immediately

MURDER & MAYHEM IN BOSTON

South Station. *Original photograph by Catherine Reusch Daley.*

began a search for the boy. An initial search was made of South Station with a cadre of fifteen police officers, but nothing was found. Daley relates that "they did not find a body. A day or so [later] I went back to the area with Detective Whitley. We each split up, each of us in different area and made an intensive search. Within twenty minutes Detective Whitely called me that he had found the boy. He had been wedged into a corner and covered with a canvas. He had been strangled."

Soon after the discovery of the body, Sergeant Daley learned that a train conductor who knew Kenneth Harrison had seen him board a train that very day and that it was a southbound train to Providence, Rhode Island. By this time, it was late at night, and the detectives wanted to call it a night—they had been working the case all day. But Daley, a self-professed workaholic, wanted to press on and go to Providence to track down the boy's killer. He convinced the other detectives that it was the right thing to do, and they went to Providence that night. Surprisingly enough, after about an hour in Providence, the detectives spotted Harrison standing on a street corner. Detective Frank Olbry bounded out of the car, chased him down and arrested him—perseverance had paid off!

After giving Harrison his Miranda Rights—at that time a new advisement of constitutional rights that all police had to give their prisoners due to the

HISTORIC CRIMES IN THE HUB

Supreme Court case *Miranda v. Arizona* in 1966—Harrison began making admissions. Daley knew he had his man! "The admissions convinced me that he killed the boy."

The next day, the detectives went back to Providence to pick up Harrison and bring him back to Boston, as he had elected to waive an extradition hearing. Daley tells us that on the way back, he confessed to the murder of Kenneth Martin, saying it was an "accident," but then began to make other confessions as well. "He was a classic psychopath and just wanted to tell all. He suffered from no feelings of guilt."

He would make confessions to Daley, to other detectives and then finally to a judge.

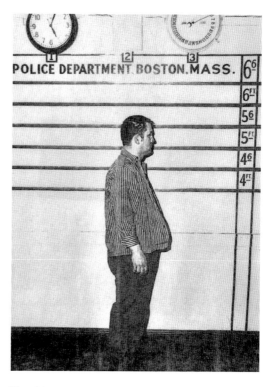

The Giggler—Kenneth Harrison. *Courtesy of Captain John Daley, Boston Police Department.*

Harrison confessed that back in May 1967, he was employed as a taxi driver and offered to give a ride to a six-year-old Lucy Palmerin from South Boston. The unknowing child agreed to take a ride with the friendly taxi driver. Later, the glib psychopath inveigled the girl into a piggyback ride and then while doing so tossed her into the Fort Point Channel—where she drowned. He also divulged that he was "the Giggler"—the person who called in the report of a "man down" at the excavation site at Kneeland and Washington in June 1969. That man was Joseph Breen, and Harrison confessed that he was also the murderer and told how he met Breen in a bar that night. He said they decided to leave together and get a bottle of liquor, but an argument broke out over who would pay for a bottle and cab fare. He revealed that in a rage he attacked Breen, pushing him into a water-filled pit, and that he hit him over the head repeatedly with a rock as Breen tried to resurface. Harrison would also confess to the murder of seventy-five-year-old Clover Parker in November 1969. He would tell of how he met Mrs. Parker on the Broadway Bridge: she had asked him to escort her

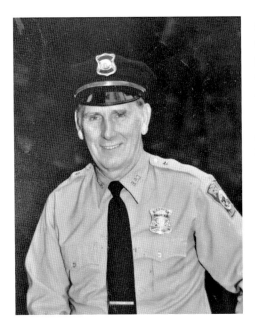

Captain John Daley. *Courtesy of Captain John Daley, Boston Police Department.*

over the bridge as it was slippery out. When they got halfway across the bridge, he suddenly picked up the old woman and tossed her over the rail.

Harrison would initially plead guilty and be convicted of the murder of Kenneth Martin in 1970 and given a life sentence. He eventually would be sentenced to three life terms in 1972 for the murders of Lucy Palmarin, Joseph Breen and Clover Parker. But he made one more frightening confession that he would not be prosecuted for. He would tell Sergeant Daley and others that he was also responsible for the Paramount Hotel fire. Perhaps due to the fact that the cause had been found to be a gas leak, the case was never pursued. But in all probability, it is likely that he was the arsonist. We know he was at the scene from the interview he gave to reporters, and he was the arsonist whom the police were looking at for the fire at the time. Additionally, in a correspondence, Captain Jack Daley told the author, "There is no doubt that he set the fire because he told me that he did it. Before the Paramount Hotel fire he had committed a previous arson and was arrested by three detectives in District 11 (Dorchester). He was tried for this arson and acquitted in the Superior Court. He was a hopeless psychopath and could be very charming when he chose to do so."

Kenneth Harrison was supposed to have served his term at Walpole State Prison, but a plea bargain was made to have him serve his sentence at Bridgewater State Hospital for the criminally insane. In 1989, he would commit suicide by overdosing on medications that he was being given by the institution for his mental illness. Apparently, he hid the pills in his mouth, saved them up and secreted them in his cell and then took them all at once.

The "Giggler Case" soon faded from prominence and never achieved the notoriety of the "Boston Strangler Case." But in the final analysis, if one examines the mortality attributed to "the Giggler," taking into consideration the Paramount Fire—Kenneth Harrison was every bit as lethal as "the Strangler."

BIBLIOGRAPHY

BOOKS

Bacon, Edwin. *King's Dictionary of Boston*. Cambridge, MA: Moses King Publishers, 1883.

Bickford, James. *The Authentic Life of Mrs. Mary Ann Bickford, Who Was Murdered in the City of Boston, on the 27th of October, 1845. Comprising a Large Number of Her Original Letters and Correspondence Never before Published*. Boston: The Compiler, 1846.

Carleton, Marjorie, Lawrence Dame, Timothy Fuller, James A. Kelley, William Schofield, Paul Whelton and John N. Makris, eds. *Boston Murders*. New York: Duell, Sloan and Pierce, 1948.

Coffin, Charles Carlton. *The Story of the Great Fire, Boston, November 9–10, 1872*. Boston: Shepard and Gill, 1873.

Conwell, Russell H. *History of the Great Fire in Boston, November 9 and 10, 1872*. Boston: B.B. Russell, 1873.

Daley, John. *Boston's Finest: Callbox to Courthouse*. Boston: CreateSpace, 2014.

Duke, Thomas Samuel. *Celebrated Criminal Cases of America*. San Francisco: James H. Barry Company, 1910.

Heard, Franklin Fiske. *Report of the Trial of Leavitt Alley, Indicted for the Murder of Abijah Ellis, in the Supreme Judicial Court of Massachusetts*. Boston: Little, Brown and Company, 1875.

Mary Warren Chapter of the Daughters of the American Revolution. *Glimpses of Early Roxbury*. Boston: Merrymount Press, 1905.

BIBLIOGRAPHY

Nash, Jay Robert. *World Encyclopedia of Organized Crime*. Cambridge, MA: Da Capo Press, 1993.

Norris, Curt. *Little-Known Mysteries of New England*. Plymouth, MA: Jones River Press, 1992.

Pomeroy, Jesse Harding. *The Autobiography of Jesse H. Pomeroy*. Boston: Boston Sunday Times, 1875.

Savage, Edward H. *Boston Events*. Boston: Edward H. Savage, 1884.

———. *A Chronological History of the Boston Watch and Police from 1631 to 1865; Together with the Recollections of a Boston Police Officer or, Boston by Daylight and Gaslight, from the Diary of an Officer of Fifteen Years in the Service*. Boston: Edward H. Savage, 1865.

Sawyer, Henry M. *History of the Department of Police Service of Worcester, Mass., from 1674 to 1900, Historical and Biographical: Illustrating and Describing the Economy, Equipment and Effectiveness of the Police Force of To-day, with Reminiscences of the Past, Containing Information from Official Sources*. Worcester, MA: Worcester Police Relief Association, 1900.

Schechter, Harold. *Fiend: The Shocking True Story of America's Youngest Serial Killer*. New York: Simon and Schuster, 2000.

Schlesinger, Louis B. *Serial Offenders: Current Thought, Recent Findings*. Boca Raton, FL: CRC Press, 2000.

Newspapers

Boston Daily Advertiser, December 9–11, 1874.

Boston Daily Mail, October 27, 1845.

———. Report on the Trial of Albert Tirrell, 1846.

Boston Globe, October 8, 1875.

Boston Post, June 27, 1865; May 24, 1875; May 29, 1875; May 27, 1876.

Colby Clan Communication, June 2004.

Daily Inter-Ocean, July 24, 1874; February 25, 1875.

Haines, Max. *Lake of the Woods Enterprise*. October 16, 2014, originally written for the *Toronto Sun* in 2003.

Hartford Daily Courant, June 20, 1865.

Independent Statesman, July 9, 1874.

Lewiston Daily Sun, October 2, 1936.

Lewiston Evening Journal, March 16, 1926.

Milwaukee Sentinel, October 12, 1947.

Nashua Telegraph, September 16, 1937.

BIBLIOGRAPHY

New Hampshire Patriot, July 22, 1874; June 2, 1875.
New Hampshire Sentinel, April 30, 1874.
New Haven Evening Register, November 11, 1887.
New York Evening Post, January 4, 1939.
New York Herald, June 21, 1865; November 8–10, 1872; February 5, 1873.
New York Times, June 21, 1865; July 17, 1865.
Philadelphia Inquirer, July 22, 1942.
Pittsburgh Press, September 5, 1937.
Reading Eagle, October 6, 1936; October 24, 1936.
Trenton State Gazette, April 25, 1874.
Tuscaloosa News, January 29, 1966.

WEBSITES

"The Boston Barrel Tragedy." Murder by Gaslight. http://www.murderbygaslight.com/2011/09/boston-barrel-tragedy.html.
Damrell's Fire. http://www.damrellsfire.com.
Laskowski, Amy. "Revelations of a Brothel's Trash." Bostonia, Boston University Alumni. http://www.bu.edu/bostonia/summer11/brothel/.
Marx, Walter H. "Bussey Woods Murders." Jamaica Plain Historical Society. http://www.jphs.org/victorian/bussey-woods-murders.html.
Nichols, Guild. "North End History—The Italians." http://www.northendboston.com/north-end-history-volume-5/.
Taylor, Troy. "The Northwood Murderer." American Hauntings. http://troytaylorbooks.blogspot.com/2014/06/the-northwood-murderer.html.

MAGAZINES

Harvey, Thomas. "The Crime in Room 406." *True Detective*, September 1930.

ARCHIVAL MATERIAL

Wood Detective Agency. Records, 1865–1945. Cambridge, MA, Harvard Law School Library.

ABOUT THE AUTHOR

Christopher Daley has been lecturing in New England for over twenty years on historical topics of interest at libraries, historical societies, schools and many different clubs and organizations.

He holds a BA in political science and an MAT in history from Bridgewater State University.

He was formerly the president of the historical society and chairman of the historical commission in Pembroke, Massachusetts, and was a docent and chairman of the educational outreach program at the John Alden Historical Site in Duxbury, Massachusetts.

He is currently a history teacher in the Silver Lake Regional School System in Kingston, Massachusetts.

He resides in Wareham, Massachusetts, on the shores of Buzzards Bay with his wife, photographer Catherine Reusch Daley; their two dogs, Grady and Lincoln; and three cats, Bo, Chloe and Penelope.